THREE KINDS OF MOTION

KEROUAC, POLLOCK, AND
THE MAKING OF AMERICAN HIGHWAYS

RILEY HANICK

Sarabande Books
LOUISVILLE, KENTUCKY

Library of Congress Cataloging-in-Publication Data

Hanick, Riley, author.
 Three kinds of motion : Kerouac, Pollock, and the making of American highways / an
essay by Riley Hanick. — First edition.
 pages cm
 ISBN 978-1-936747-90-0 (pbk. : acid-free paper)
 1. Kerouac, Jack, 1922–1969—Criticism and interpretation. 2. Pollock, Jackson,
1912–1956—Criticism and interpretation. 3. Art and literature—United States—
History—20th century. 4. Interstate Highway System. I. Title.
 PS3521.E735Z666 2015
 813'.54—dc23

2014028106

Cover image by Ruokun Yi. Image provided courtesy of the artist.

Cover designed by Jonathan Graf.

Interior layout by Kirkby Gann Tittle.

Manufactured in Canada.

This book is printed on acid-free paper.

Sarabande Books is a nonprofit literary organization.

 The Kentucky Arts Council, the state arts agency, supports Sarabande
Books with state tax dollars and federal funding from the National
Endowment for the Arts.

Exit 244 Off I-80 to Park Road

On the third week in January, upon lacquered concrete reflecting white light, in a plexiglass box measuring one foot by one foot by one hundred and twenty feet, transparent through five sides with black fabric on the sixth. Gently, with white felt gloves, they have laid it out complete. There will be two guards standing at the entryway. Each will clasp his hands in front of him and look ahead.

•

Jack Kerouac started speaking English at age six. At seventeen he wrote a mystery story for his high school's monthly journal and at twenty-five he stayed up for three weeks taking Benzedrine with coffee, clenching his jaw and writing a draft of *On the Road* on one scroll of paper. More than a half-century later, it is being displayed at the University of Iowa Museum of Art. It has come to us courtesy of Jim Irsay, who purchased the scroll for two million, four hundred and thirty thousand dollars. He also owns the Indianapolis Colts. In a few months the scroll will continue on to Orlando, Indianapolis, Austin, and Vegas. We're part of a thirteen-city tour.

4 It is ten in the morning and completely clear outside. He wakes and it's as if it is there in the room like taut, even light on the wall, and his first thought of the day is that today he will be unable to begin.

1919. Ike at Camp Colt. Ike at Fort Benning. Ike at Camp Meade, bored with demobilizing troops. The federal government and the army are generally convinced of the need for better roads. Publicity is a good idea.

Ike selling the Seedling Mile. Ike in Stetson hat and green tunic. Ike in a two-mile convoy. Tire manufacturers, truck and auto companies, *good road boosters*. Among eighty-one military vehicles there is one small tank on a flatbed trailer. Also a blacksmith shop on wheels, a gasoline truck, a wrecker. A van pulling a three-million-candlepower

searchlight. The U.S. Army's Transcontinental Convoy will take two months to slog from Washington to San Francisco, averaging around five miles per hour. Half of the roads are sand or mud, routes careening aimlessly, connecting by accident. A map of the highways would look like a scatter of snipped yarn ends, dissipating to the west.

It feels wrong for there not to be silence. Before you see the case or the guards, there is a mangle of sound that is nearly enough to keep you away. Walking down the empty hallway toward the museum's new wing, I'm given an impromptu mash-up of "Koko" and "Subterranean Homesick Blues" which quickly becomes a jubilant mumble of bright mud. There is a mix CD on repeat. There are film and video clips. Their accumulation is attempting to acknowledge our desire for context, while simultaneously enacting our desire that context be obliterated. I sit and listen and try to see it through. The clips recombine and contort and mostly their enthusiasms seem grotesque and deflated as they plow into one another.

5

The display case stretches from the gallery entrance to the north wall. Inside you can see it, tattered and mangled for the first few feet and then smooth, aged to a light beige, a yellow crust where tabs of scotch tape hold the sheets together. A display panel explains that the scroll does not appear to be Teletype paper, as Kerouac claimed, and that each twelve-foot strip had to be cut down to a width that would fit into a typewriter.

Also, to the right, before the hallway, on the hushed side of the white wall that stretches three-quarters of the way to the ceiling, in front of two black leather chairs with matching footstools: Please enjoy the most valuable object in Iowa. Commissioned in 1943 for Peggy Guggenheim's entryway to her Manhattan townhouse, Jackson Pollock's *Mural* is eight feet by twenty feet. Four years later, she moved to Venice and it was given as a gift to the University of Iowa. People said she was sleeping with the museum's future director. It's also said that while the museum was being completed the painting spent part of the winter in a barn, where birds shit on it. All apocryphal enough, though it has been acknowledged that for a short time the painting hung just beneath the rafters of the university's library, where there were also, occasionally, birds.

1956. Ike emphasizes benefits to the economy, the need for security in evacuation, and the essential role of information unity. Estimates state that two-thirds of an urban population will be decimated in the event of a nuclear attack. In another war, Ike noticed the autobahn. He is generally opposed to advertising along the highway, but admits he rather likes reading the Burma-Shave signs to himself as he drives from Pennsylvania to Washington.

Horizon slips. Shadow and light tail each other insensibly. Nests freeze to branches. Outlines swell with snow. For Husserl, every experience *points to further experiences that*

would fulfill and verify the appresented horizons. For *appresented* read: something like a prism. Something like a sprawling halo upon each thing, asking after every option, every angle and direction extending into diffusion. A prospect. Ether. The watering of a lawn. The radio relays new findings on increasing thickness and reflectivity in clouds. The term is *global dimming*, though from space we are, in fact, more luminous.

And there are other terms: *auto-*, a prefix embodying a capacity for propulsion, containment, and self-combustion in equal parts. Chief meanings include: *(a) of oneself, one's own; (b) self-produced or induced (pathologically) within the body or organism; (c) spontaneous, self-acting, automatic*. A line of cells. A player piano. A thing pressing out from the unseen, both source and effect, occurring without us; an opening somehow limned in.

Notice the remains of Roman roads. The *viae*, meaning *way*, but etymologically related to *weight* via the Indo-European root *wegh-*. One walks briskly, without thought, so that collapse is almost imperceptible.

Lines lengthen and recede at the right margin of the scroll, stair-stepping to the edge of the page, until the margin retracts to its starting point and begins again. As I walk the length of the case, I hear one guard talking to the other, asking if he has seen the part up here, near the top, about Des Moines.

"He was in Des Moines?"

The older guard leans over the scroll, "*There were the most beautiful bevies of girls everywhere I looked in Des Moines that afternoon*—how do you like that?—*they were coming home from hi school—but I had no time now for thoughts like that and promised myself a ball in Denver*—see that?—*the most beautiful bevies of girls everywhere I looked*—right here in Iowa."

The View From East Sixty-First Street

Say it begins with Pollock nodding while Peggy's hands sweep in the air along the long shallow vestibule to show where she thinks she might place a sculpture, there, toward the far end of the still-blank wall he is staring at, then measuring with the tape he has pulled from his coat pocket. Say that, since the hypothetical turns back so easily to refract itself, he simply doesn't know what to feel and so will attempt to imagine the reception afterward. How the sound of the elevator gate closing will become more familiar each time he returns and adds to the wall,

though perhaps it will sound different that night when it closes in front of him, a little less loud than the braid of chatter and laughing he will hear as he begins to descend and is it because he has made them happy or because they were humoring a buffoon but why would she have asked him if she thought he was a buffoon or has it taken her this long to realize and now she's stuck with it and now she is saving face, asking friends if they think it might look better beneath a curtain rod or how long it will take someone to paint over every inch of this mess.

He thinks he might have copied the measurements down wrong but doesn't want to do it again. She invites him to see the rest of her place and he says sure. Like everyone else, Jack is generally mystified by Peggy's relationship with Kenneth Macpherson, who does and doesn't live with her in the double-fronted brownstone, the top two floors of which they are walking around in. And technically, it's a duplex, she tells him, and Kenneth has more or less ridiculous taste when it comes to interiors, so they split it and anyway he's not around today. They spiral up the black Regency staircase while Jack is thinking about the big white wall and the white wall that faces it, and the room behind the wall and the white rugs and furniture between the other white walls of Kenneth's living room and the full chrome bar in the corner, gleaming on small wheels. He tells her that he likes her living room more than Kenneth's and presses his palm to the corner of the large stone mantel above the fireplace and feels a little hurt

when she says well, he has to say that, because it's true, he does. Maybe he is afraid to sit in the chair that looks sort of like an aardvark. Or she wants him to ask about a Yoruba sculpture on the mantelpiece but he does not. She explains that her living room had been the servants' quarters and they'd had to knock out three walls to make something suitable and now there was only the oddity of having four bathrooms on the same floor. He nods and walks toward the window and resists the urge to pass his fingers across the chair rail that encircles the room. The door to his left is open: every earring she owns is arrayed and hanging on the far wall.

On Enticement

I read the first fifteen or twenty lines and find my attention drifting. I scan the length of the scroll, enjoying the faint pencil-marks and undisguised first names. I walk to the north end of the gallery to find the comparatively quiet sound of Kerouac's voice, recorded during his appearance on *The Steve Allen Show*. An early hardback edition of *On the Road* is propped open inside another display case.

The video loop at the other end of the room is cycling through clips of beatnik caricatures in sitcoms and

films. Eventually the screen cuts to an excerpt from Stan Brakhage's *Text of Light*, a short film composed entirely of luminous patterns viewed through a green glass ashtray.

To say that Peggy may have slept with a museum's not-yet-director is to say almost nothing, since she actively sought to sleep with lots of people. She collected their names, keeping a running list in her diary, something Kerouac also did. Most biographies say Pollock was soused if and when anything ever happened between the two of them, and usually qualify the encounter as *unsuccessful*. We might call Mary McCarthy's claim that Peggy *supported everyone she'd slept with and everyone who'd slept with anyone she'd slept with* hyperbolic, but this will not explain why she gave the largest Pollock canvas she would ever own to an institution that had no obvious place to put it.

Of Kerouac and the newly set world record for the single highest price ever paid at auction for a literary manuscript, Jim Irsay will say, *Wherever his spiritual vibes are floating around he can feel good about it.* If anyone else had kept on bidding, *I was willing to spend a lot more.*

Peggy's plan had been to accompany Jackson's first solo show with the unveiling of her newly decorated front foyer. It would be a big night. She had already sunk enough into him to feel a little anxious, paying out one hundred and fifty dollars a month for the entire year so he could focus

more fully on his work. She would deduct this from the total sales from the show, plus a third for her commission. If the gallery made more than two thousand and seven hundred dollars, he would get paid, and if it did not he would make up for the shortfall with more paintings.

This kind of speculative arrangement was exceptional to its time and country, whose art patrons generally paid for what they could see or walk away with. Because she chose to purchase broader expectations, Peggy made Jack part of something new.

He celebrated the deal with dinner at the Minetta Tavern and a double feature at the Tsquare movie theater. He sat jangling his knee through *Dracula* and *Frankenstein* and bought rounds at the bar and had a good roaring drunk in a nervous elation appropriate to what he was, which was open and unknown.

Three years in advance of Peggy's commission, Paul G. Hoffman, president of the Studebaker Corporation, argues that the Turner Thesis can be extended to highways and their development, which are *a new national frontier for the pessimist who thinks frontiers have disappeared.*

The suggestion that *Mural* be executed on canvas rather than a wall was made by Marcel Duchamp. It feels odd for him to turn up here, offering practical advice, less so if we remember what mobility had already taught him. That his *Large Glass*, just after he declared it *definitively unfinished,*

was modified by the web of splintering cracks that were added to it over the course of a truck ride from Brooklyn to Connecticut in 1927. He replaced some sections and kept others, where the radial arcs were nearly symmetrical, where he saw *a curious intention* that he was not responsible for, one he respected and loved. In 1941 he completed a portable museum, arranging miniature reproductions of his work into a cloth-covered cardboard box that fit inside a single leather valise. He smuggled elements he needed out of occupied France, posing as a cheese merchant. Call mobility a form of potentiality, an opportunity for cunning.

Jack's mural is not nimble, weighing a little over two hundred pounds. When Peggy left New York he was still obscure enough for university officials to balk at paying the shipping fees, which came to nearly one hundred dollars. As Jack's painting evades the wall, its title forgoes the truth of redundancy. Metaphor, it's said, is a vehicle. If the frequently restated triumph of the abstract expressionists will be that they stopped painting pictures and began to do something else, we may seek to be forgiven in advance for lingering at this interstice, remaining lodged, uncarried.

Name your painting *Painting* and a self-evident doubling may clot.

Name your painting *Mural* to begin beneath the sign of a lost object or function.

•

Paint a wall you own and it is an investment. Paint one you walk past on the way to work and it is a crime. We should not have to tell you these things.

Retain a view of the room as matter; as in *what* or *what's the*. See how the stress falls on the pain or becoming-public of paint and expression. How it comes into view or is given, as an occasion; of light and compromise, *impaired by the eyes of the unfeeling* as Mark Rothko saw the exchange.

I stand and stare at the shapes Jack made. A painting may come to understand itself within the terms of singularity and contamination—as the temporary victim of a room and what is outside of it, or as a claim to what could stand outside of victimhood or figuration, if these are the words we are seeking. And if this dreamed or dreaded agency or its relinquishing is both a painting and not a painting, relinquishing the world to mark belief, if it sings with a tantalizing sense of being so nearly finished, so nearly done with painting and feeling entirely—why then do we seem so tedious in the circuit of its stare, feeling fleeced by its demands?

Venice, it's said, fit more fully with Peggy's regal air. Toward the end of the century, it will be said that the second half of our respectable lives will be spent acquiring real estate, after we have spent the first pursuing sex. A

painting pays so little fidelity to a room. Because Jack's painting is now a little like a steamed stamp, it can also be saved from a fire or a planned demolition or the decorating impulses of obtuse future residents of the double-fronted brownstone that Peggy had some fond memories of, but is happy enough to leave.

1943. Kerouac drops out of college, joins the military, and ends up in the mental ward of a navy hospital in Bethesda. He will eventually be given an honorable discharge. *Indifferent character.*

Drywall crumbles around a sledgehammer like burnt toast under a tack. There is no shortage of things to be overcome. Nothing really selling from the AOTC show and Sweeney writing in the catalogue that he had no discipline. In the goddamn catalogue. They had spelled his name right this time, so everyone could know it wasn't *Pollack* that had no discipline, wasn't *Pollack* sweeping gallery floors for Hilla, that crazy Prussian bitch, with her spies in every other corner monitoring your conversations. Plus, it's just not that easy when one must always and all at once be unconsciously animating the manifold texture of man's soul. The Warrior, the Orphan, the Lover, the Sage. The King and the Magician. The Fool.

Lee had barely protested. She had even helped out. He simply needed more space. While we expect it to be him alone, roaming between their studios, terse, swinging and sweating and laying the walls down to jagged piles

of dust, Lee was the one who packed the wall into buckets and helped carry it to the curb. Maybe an easel at Ruben Kadish's on Twelfth Street was fine. Maybe she found another place a few weeks later but was quiet about it, or it was easier to work away from him. Maybe if she'd insisted on a corner, on keeping something, or that it didn't have to be so damn big, he wouldn't have become famous for being Jack. But that is not how the story goes.

The suggestion to write something about the exhibition of the scroll was made by my mother. She remembered me always reading him in high school and since the local paper would want to cover it one way or another, why not try to submit a freelance piece? I didn't know why Kerouac had become embarrassing to me and I didn't try to explain it. I said it sounded like an idea and drove there later that week with a notebook.

Jack, Asked About Visions

It begins as a stampede—a sweep of haunches—eyeless black mares, quivering. Then buffalo, then bulls and jackals, panic. It finds itself being carefully layered, famously cloaked. It likes itself more. Now it has options.

And said what he said about his dreams and *a landscape the likes of which no human being could have seen* or the consolations of the inhuman. That, when it is a painting, you can turn away. Walk across the river to watch grackles fill a tree,

then rooftops outlined in lightning and wanting it precisely like that: tangible, epiphanic.

He did not elaborate on the stampede as a dream or a memory, though he did pronounce a kind of judgment in that throwaway mode of talking he liked to live in; not saved, not riven, not one, not many but *every animal in the American West, cows and horses and antelopes and buffaloes. Everything is charging across* that surface, which he damned.

It took him six rides, a day and a night to get from Joliet to Des Moines. He got a hotel room next to the railroad tracks and slept through the afternoon, into morning. He slept so hard he forgot who he was.

It slips relentlessly from your attention, so you can pass in anywhere. Everything is quickly being scumbled: drawing and painting, figure and ground, stasis and momentum. Every urge leads to looking everywhere.

Adel, Stuart, Council Bluffs. White sun. Jack thought about hopping a freight, but he didn't know how.

Stampedes are more frequent at night, in the midst of thunder or hail. To keep from falling asleep in the saddle you might try lining the inside of each eyelid with a dab of tobacco juice.

•

The train station now serving Des Moines is somewhere in Osceola, about an hour from downtown. There will be an indeterminate space surrounding any abandoned train station you can see or imagine. Perhaps you will walk around it, looking for whatever resembles an old hotel. Like lots of people, Jack liked to read into the precipice of sleep, where words grew muffled and damp, past the point of noticing where or when what congealed into waking stumbles and slumps. A kind of deference there. A kind of spherical vent.

Duchamp, who said that painting was nothing but a bridge. Eventually, he said, he came to hate it.

The Problem of Being Touched on Every Side

Herds of cattle can be calmed by a continuous sound and so were often sung to in the evenings by a figure slowly circling on horseback. A song could become useful by resembling a blanket; by being slow and continuous, a thread of tuned breath disappearing into moonlit steam rising from the animals. It could be called "Wild Rippling Water" or "The Strawberry Roan" or "Little Joe, the Wrangler," perhaps the most well-known song to narrate a death by stampede. Its final lines glimpse the body in a washout twenty feet below, mashed to a pulp under his

horse, *his spurs had rung the knell*. Such a death was commonplace. Remains were buried where they were found and the group moved on.

The creatures that compose a crowd have a power that they are simultaneously cut off from and absorbed by as they become a stampede. Such moments are preceded by a sequence of others; some of them are simple. A song becomes a comfort by growing familiar to your throat, a thing that can be sung while thinking of something else. And so it is strange when something catches; a word you have mouthed a hundred times on a route walked daily for years. A stampede is preceded by a need to be together in the same place, for orientation or warmth or to see something happen. The human stampede is inextricable from the age of crowds and headlines. One thousand three hundred and eighty-nine people are trampled to death at the coronation of Nicholas II at Khodynka Field in the crush for promised gifts; more than four dozen are trampled in a Metro station at Minsk a century later. Eleven people are trampled to death when The Who play Cincinnati in 1979. Twenty-one in Hong Kong on New Year's Day in 1993 and the same number in the same way in a Chicago nightclub's stairwell a decade later. And how many hundreds in soccer stadiums before or after matches, in tunnels leading away from reserved seating or in the surrounding streets, in police riots? And the one thousand four hundred and twenty-six trampled in al-Muaissem tunnel in 1990 during the Hajj, or the two hundred and seventy trampled at Jamarat

Bridge during the Stoning of the Devil in 1994, or the two hundred and fifty-one trampled at Jamarat Bridge during the Stoning of the Devil in 2004, or the three hundred and forty-five trampled at Jamarat Bridge during the Stoning of the Devil in 2006, or the estimated one thousand people trampled in Baghdad on August 31, 2005, when rumors of a suicide bomber rattled through a crowd of pilgrims that surged across Al-Aaimmah bridge.

On Entrapment

Though mostly it is immobility that precedes this painting and makes its crisis possible. Mostly the frenetic bluster of *Mural* is suffused with the crowded nervousness of a single room, with the work of his waiting; the dissipation of any initial excitement, his coming and going without touching a brush, his pacing amid cigarette butts and well-rubbed rags. Being bound to it for hours. The hours of the day, the days of a week, month, and passing season. The story of Jack's inaction will move from monographs to biographies to film scripts, where such a waiting cannot

readily be pictured, though it nearly goes without saying that we need it for the story. If we have tried to love him in his waiting it is because we would like to imagine our lives in similar terms.

A scroll appeals to the way we believe in texts. That in extension something will be revealed. On a plain white cloth, beneath well-labeled evidence. In an uncurled genome, in Teletype. Papyrus unfurling like a bloom or shoot. Say that truth has a shape to be seen, an unfolding where nothing is hidden. Or that the shape of a scroll is fundamentally optimistic, like a diagrammed ray, or youth. Believe this if you find it appealing.

The country's early attempts at highway construction had decidedly mixed results. Some states tried lining the road-bed with hay bales and building on top of that. Others made highways out of crushed oyster shells.

Or say it begins with Peggy showing up at Lee and Jack's apartment on Eighth Street at the appointed time on a Saturday afternoon to find no one home, though they will arrive a few minutes later to rewalk the stairs with her and unlock the apartment door.

In Iowa, stretches of macadam periodically interrupt the uneven mud. A promising material, easily graded; a crush of limestone or granite. Its binding elements are nearly

nothing. They are moisture and rock dust. Because macadam is made by an act of fracture and because it is stone, it feels both modern and old.

I had been living in my parents' basement for a few months and working part-time painting houses, offices, and apartment blocks. The house they had recently moved into had an exterior made mostly of long, dark horizontal slats. Each was made with some combination of wood pulp and plaster or masonite, eventually blended with concrete for better insulation, as was explained to me. I painted them dark gray in the garage of an industrial park during the winter and was paid by my father. Every few days one of the slats would teeter over and then everything propped beside it would follow. I touched these up again but it didn't really matter since, after they were stacked into the bed of a truck and driven to the house, we saw that there were nicks and spots all over each one of them and eventually someone else was paid to just spray the whole thing in a day. I think my dad knew I needed something to do.

My parents' new house was poised at the summit of a sloping meadow near the edge of our town's largest park. A little more than three years beforehand, I had graduated from college and moved to Boston with A., who left me. I stayed there another year because I had no idea what else to do, and moving home had seemed too pathetic. It was nice to have decisions made for you, to simply run out of savings and sporadic temp work and

repair to Iowa. For months we had no neighbors. The development of the land we lived on had been met with a fair amount of public resistance, which I had remained largely unaware of while away, mired in a strange and radiant self-obsession that grew more desperate with time. I came home and was approached at the bar by near-strangers from high school who wondered how I'd been and if I knew how many decades it would take to restore the prairie that had been built upon and I told them I did not. There were deer and wild turkeys visible from the living room. Swallows nested beneath the porch and pitched into the late afternoon light in long oval loops. We came home and surrendered ourselves to the delirious sunsets that soaked into the living room couch. We continued to speak of these, even after another house went up directly in front of them. Winter came and we saw that the newer house had a heated driveway that melted all snow on contact.

One of Lee's paintings hangs in their living room. It is the first thing Peggy sees. Jack had quickly become unpresentably drunk at a wedding that morning, then slept in an unlit back room until the ceremony was over and Lee began pouring coffee into him. Peggy squints at the corner of the painting, growing progressively upset because it says *LK* and she neither knows nor cares who the hell *LK* is, though she knows she is not here to see anything

LK might happen to be doing for whatever purpose, need, or renting beast she might feel bound to; so could you please show me something that might mean I have not wasted my entire afternoon and will you please do it now?

Jack Encounters Two Russian Actors

He walked off the field in the middle of marching drills and into the naval library, where he sat down to read and take notes, alone at a large table, until military police arrived to detain him. The earliest readers of Kerouac's first novel were psychiatrists at the base hospital trying to determine whether or not he should be court-martialed. It had been written by hand and entitled *The Sea Is My Brother*. The base hospital wasn't so bad. He will remember having an enormous friend who called himself Big Slim and that in the mornings Slim liked to wake Jack up

for breakfast by lifting his mattress with one hand. He told stories about working in Texas oil fields and on tugboats in New York Harbor and later he taught Jack a few ways to cheat at cards. Jack will be transferred to a grimmer naval hospital in Bethesda after he runs naked across the drill field on a Saturday morning, but before this happens he will meet two movie stars. Leonid Kinskey, who played Sascha the bartender in *Casablanca*, and Akim Tamiroff, who got an Oscar nomination earlier that year for playing Pablo in *For Whom the Bell Tolls*. Jack is upbeat, a little giddy standing in front of them, though also a little blurred, unable to make it clear that he has not begun to spoil. He trots out a little routine of fast-talking nonsense and keeps at it for a few minutes to entertain them before they move on.

Interim

The transcontinental convoy marked the path of the forthcoming Lincoln Highway with salmon-colored paper triangles. They tacked them to fences, trees, or posts, indicating each turn with the direction of the triangle's tip. Placing one atop another to form a diamond at each point where they stopped and made camp.

They found themselves becoming an occasion for parties as they rolled west, beneficiaries of the bottomless need of small towns in the middle of nowhere to outdo one another. They were fed fried chicken and ice cream

and watermelon and hot donuts and lemonade. Farm league baseball teams inevitably challenged them to field a squad that they could kick around for a few innings before the game was called. There were parks and bandstands. They danced to Shean's Jazz Orchestra in Clinton, Iowa, after the Goodyear Rubber Band traveling with them was recalled by the government. It had been stipulated that the convoy would not advertise any particular product, though it was also true that shilling for tires was inseparable from the syntax of road-boosting and that this, along with military recruitment, had been pitched as the primary side-benefit of the convoy. Within a few days the decision was reversed and the band stayed on until San Francisco. The fender of their two-wheeled kitchen trailer fell off as they left in the morning.

I drive back to the museum to watch the Brakhage film again, but in the display area every seat is taken, perhaps in part because the paper ran its write-up two days beforehand or simply because it is the weekend and the plows ran all night and now we can leave our homes again, and without thinking I walk into the next room where a temporary exhibit on "The History of Iowa in the Art of Maps" is chronologically displayed on four walls. I have a hard time getting past the first print, which reproduces Waldseemüller's 1507 world map, the first to depict a new continent, shorn entirely from Asia, and to name it. The Library of Congress bought the original for ten million

dollars. Other maps make the ground unrecognizable; some are hand-colored, positing an island of Canibali in a southwest corner, a single brown human leg hanging like a pendant from one branch. Some are speckled with marvelous cartouche, their borders and demarcations suddenly springing with leaves and compact whorls, pieces of fruit. In another corner, in the blank space outside a map of the world, is a second map. Here there are concentric nests surrounding the earth, labeled as *Aer, Fyre,* the *Moon Cold and Most Benevolent.* It floats inside the *Christaline Heaven, The First Moveable Heaven,* and the second.

Or it begins with Peggy approaching Piet Mondrian, who is among the jurors selecting work for her spring salon from the submissions crowding the floor and leaning against every wall of the room. Mondrian is standing in front of Pollock's *Stenographic Figure,* quietly deciding that it is his favorite in the group when she arrives beside him and says, *That's not even a painting, is it?*

In 1904 the Iowa State Highway Commission is established in Ames, where it will spend most of the next fifteen years persistently arguing for the creation of a state system of public roads. The existing policy calls for roads to be maintained by each farmer whose property they abut or run across. Most roads are made of clay or loam or whatever is at hand. Such roads are prone to muck.

•

In the naval psychiatric ward Jack writes on the stationery they provide, an etching of a battleship hovering above his penciled scrawl. A patient has passed him two aspirin, which he takes with water while the man's eyes paw at him. That afternoon they will watch war reels. He writes, *I can blame all the unrest of the spirit on my nervous system.* He writes, *I can't stand it when the patients drag the steel bunks across the concrete.*

Mondrian, who was Lee's first example when arguing for her choice to leave her paintings unsigned. Hadn't he made it obvious, she asked Jack, that the formal balance of a canvas can only be disrupted by an artist's signature? Jack, having none of it, grabs a brush and does the first one for her. Fine. She will compromise by placing two letters in one corner.

A stick is broken by the wind or a match flares or something unseen lets out one cry and then there is no stopping. This is what feels inexplicable about a stampede: that it is made, somehow, like a torrent is made, that a minuscule compression can shove itself into extension and be immediately, irredeemably overwhelmed. There are explanations that employ mathematical models of swarms and explanations making use of the Majestic Bull Theory, and explanations rooted in the role of the endocrine system, but they are unsatisfying even if they are true. For Jackson, who would come to hate himself for talking as

much as anything else, something was there that was like permission, something in the word or the air around it, in the snap and twitch and clamor of the air where it begins, where an instance could dissolve the scale of consequences and it simply would not matter if there was a difference between rage and jubilation or caricature and terror, or that Charles and Sande had shown so much more promise, or that he could never come up with any easy prattle, or that Dad was a washout or that people were frightening and boring or that he couldn't draw hands. Something could happen that was ruthless and unyielding, that was solid and thick and somehow almost effervescent. Somehow it is hanging on the wall.

Please Notify an Attendant

A year after Kerouac completes his scroll, Brakhage shoots his first short film in San Francisco. It opens at an intersection. The stoplight changes and a string of six cars begins to drift away from the camera while those facing it brake and accumulate at the left edge of the shot, where a figure walks along an adjacent railing. We watch his glacial movements and expressionless face; hand in pocket, hand with cigarette. The sound and pressure of traffic pushing across the viaduct that we imagine trembling steadily beneath his shoes. The warehouse and bare trees he turns

to look toward as the sound drops away and the railing shadows his legs. A thin black cable runs diagonally across his view, attached to a wooden pole his profile momentarily obscures. Then a brittle glass piano arpeggio and the shot dropping down, moving left across a switchback staircase that runs parallel to the thin black cable and behind him the sound of brakes screeching in stock audio and a car leaving the frame as he turns. He moves down the staircase with something approaching urgency, coming to the foot of it and turning to walk into the underside of the elevated highway.

After A. left me I was offered the last bed in a house where between seven and ten other people were living and I took it and found a job as a security guard in a parking garage where I tried to spend most of the day reading or scribbling into a notebook. It seemed possible to continue doing this indefinitely. Winter came, then stayed. Record-setting snowfalls and the smell of socks scorched on the space-heater in the booth, which was a piece of plexiglass interrupting the wall I sat inside. Cars eased down the ramp and I nodded at them. I wrote many letters and did not mail them. I was consistently reprimanded for inadequately concealing my distractions beneath my clipboard and I apologized for this and bicycled home in the early evening to softly obliterate myself in the expected ways, and gradually I began to enjoy the familiarity of a uniform. The way it eliminated one of the day's decisions.

A letter was written to Lawrence Summers, and one to Nietzsche. One to A.'s mother, one to her sister. I was flabbergasted when I ran into them on the street a week later, while unclipping my tie on the way to lunch. Her sister was often kind to me and said, *We really don't think any less of you,* and I said that I appreciated that very much.

Clinton, where a decade earlier the roads were a sequence of long wooden blocks, laid horizontally, soaked in creosote.

Beneath the viaduct we watch his buckled boots move in and out of shadows and light, over penumbral swatches of lit dirt, disappearing into their edges. Rows of thick hexagonal pillars shrink into the distance behind him and the camera lingers at the base of the one nearest as the figure moves away from sight, letting the pillar fill the frame. The lens inches up. Concrete, when filmed, has the appearance of thick dim fog, all but disappearing aside from the scattered damage of scuff-marks, chips, and scratches. The premises behind the coming decades of Brakhage's work are almost simple: visibility is made by light and interruption, and film stock is oddly open to registering anything slight. Pollen, seeds, thin washes of pigment, the wings of insects, and scratches, thick and thin.

To retool or remove a thing from a purported or feigned purpose; to be made unusable and therefore admissible as Art or the dream wherein Art is largely indistinguishable

from a thing seeking again and again someplace new to affix its signature.

Or, Duchamp proposed, you could paint the cracks back on, painstakingly, in gray.

In a notebook Kerouac writes a poem of anonymous French romance. She paints his portrait in oils and hangs green vine leaves on the wall and they eat at the café Chat Blanc each Sunday in April and so on. Regardless of how bad it is as a poem, the fact that it hasn't been included in a posthumous collection makes it feel exceptional, at least to me. I tumbled her, he says, *within sight of / Chartres,* then pointed out the *junction of the road where Patton passed,* and I'm guessing that in his dream of her, she was impressed. Access to this archive required that I fill out a form in which I claim to be a scholar. The room where I wait for numbered items to arrive is air-conditioned and feels esteemed in its furnishings. In my fantasies I explain things succinctly and without a fuss. In one correspondence I kept she said, *I have thousands of simulated conversations in my head in which I say my piece.* She told me that a *woman was polishing every piece of crystal in the chandelier, so there was a pleasant tinkling every time we went into the actual auditorium.*

1919. The roads were crap, they said, and they proved it by beating the hell out of them, shuttling overloaded trucks

across bridges and culverts that heaved and collapsed. In Utah, while trying to haul a truck through a soft patch of sludge, a tractor cracks through the road and sinks into another four feet of mud. They try pulling it out with a steel cable, which snaps, rising thirty feet into the air. Cue relief map with oversized Ike-head on oversized Cadillac. Cue banjo and follies kazoo. Ike gets bored, enjoys a prank. At night, atop cliffs in Wyoming, they play at being coyotes. Ike and friends play at being whooping Indians. In the afternoon they prop up a dead jackrabbit in a bush and wait for nightfall. They have an easy time persuading some Easterners to drive out and do some shooting. They'll hop out of the car and stop at a distance from the bush and say they can see it there, then that Ike can shoot it. Then he does. His cohort runs and grabs it, then walks halfway back and raises it in illustration. When he throws it aside the Easterners will cry waste while the boys say the meat is too tough and stringy. They argue from forty yards away and win. *No matter how unappetizing the ordinary jackrabbit, we didn't dare let them see one which had been shot twelve hours earlier.* Kicks.

In 1904, according to the first census of American roads, around seven percent are paved. The office providing this information was established eleven years earlier within the Department of Agriculture, as the Office of Road Inquiry, beginning largely as the result of a petition to Congress drafted by the League of American Wheelmen. Their

most prominent member was Colonel Albert A. Pope, whose manufacturing company was the country's leading provider of bicycles.

1904 is also the year that Halford Mackinder, while serving as head of the Royal Geographical Society, will present a paper at Oxford University entitled "The Geographical Pivot of History" in which he will seek to set forth what it might mean, to both academics and citizens of the Empire, for the age of geographic exploration to be effectively over. *The missionary, the conqueror, the farmer, the miner, and of late, the engineer, have followed so closely on the traveler's footsteps that the world, in its remoter borders, has hardly been revealed before we must chronicle its virtually complete political appropriation.* Within the newly closed space that now defines the planet's mapped surface, he says, events tend to echo.

There are creatures in the menagerie at Tenochtitlán that Cortés cannot stop looking at. Odd, majestic amalgamations. Crooked shoulders, a bunch upon the back like a camel, though not as steep. Dry flanks, large tail. A neck covered with hair like a lion. It is cloven-footed. It stares the way an animal stares, as if it is constantly preparing to speak. Its head is armed like a bull, *which it resembles in Fierceness, with no less Strength and Agility.* The bison, he declares, is a wondrous composition.

If a problem cannot be solved, goes an oft-quoted phrase of Ike's, *enlarge it.*

•

The convoy trudged westward through Tooele and into the Utah desert, which had been without rain for more than a month. On the back of one truck they carry the enormous floral display of a truck, which they had been given in Salt Lake City. Wine-red petals flaked from the trailer bed into the wide riveted pattern of tread tracks behind the wrecker, or across the aquiline curves carved upon the desert by wind, or into the trembling, skittering road as it became a blend of *alkali dust and fine sand, often to a depth of two feet, peppered with chuckholes.*

I was sixteen and generally miserable, like you were. I read him in early evening and felt something shake open, and could not say why it was this that I wanted to hear.

1951. Two nights after he finishes the scroll, Jack's wife of six months throws him out of their apartment. She supported them both, waiting tables at the Brass Rail. Her name was Joan.

Thirteen years before Mackinder's address, the British repeal a law declaring that every vehicle that travels across public roads must be preceded by a man on foot.

In an article published during the century's final year, Carol Mancusi-Ungaro points out that the painted-in-a-night story attached to Pollock's *Mural* cannot be entirely

true. There had been plenty of waiting and it was mostly finished fast, but the painting is all oil, with *swathes of flat color applied over previously hardened brushstrokes and dried drips*, unsmeared. Plus, there are photographs. First, in his studio soon after finishing it, then three years later in Peggy's lobby, where distinct new shapes emerge. Dark swatches turn a shade of blue.

Early surveyors plodding across Iowa's mostly dirt roads gave portions of their letters over to comparisons and venting. The roads were paste and they were molasses; they were treeless swamps and hellish stews. The phrase *Iowa gumbo* catches on. They rolled slowly across our soft and softening loam, rich in putrefaction, thoughtless and harrowing in its dexterity as it encompasses a wheel in three feet of mud after a night of rain, drying the next day into jagged, flinty ruts. Though it is also true that a single stretch of awful road could sustain the stub of a town within sight, a town that a person might look in the direction of while standing and pulling up on the back bumper with three others; a town you might then be walking toward, punctuating your steps with curses that move apace with the vague circling question of what it is that feels both common and odd and almost chosen about this particular point that cannot cooperate enough to let you through. That keeps you there to watch it. It repeats itself at your feet as you grunt and push at the stupid flung mud, repeating that you should have expected it. You should

have looked around. Look at those ruined shoes and trousers. This is the world spraying from your free-spinning wheel. This is the world's skin all over you.

1942 becomes 1943. Kerouac turns twenty-one. He wants to write and to travel. This is the year he will enlist in the navy. He has gotten used to being beautiful and precocious. He graduated high school young, two months after turning seventeen. On the day that he did, the military of the United States was slightly smaller than that of Romania.

Horseless carriages, to be precise. And your man must wave his red flag ably as well.

Just as the richness of our soil was inseparable from its ability to become a near-bottomless sludge with every spring thaw, so the disgust of early road-boosters was worked into a broader pitch, which went as follows: what good is an abundance of anything if you have to haul it across this impassable mess to get it to market? Another phrase caught on: *Getting Iowa Out of the Mud*.

The work of the Beats occasioned famously negative reactions from older and more esteemed writers. Not writing but typing, Capote said of *On the Road*. Not writing but plumbing, Beckett said of Burroughs and the cut-up method. The value of a dismissal is its brevity, the ease of

its acerbic click. *Appears to have been painted with a broom,* reads an early review of Pollock's.

Donald Rumsfeld likes Ike's oft-quoted phrase enough to include it in a list of rules, reflections, and adages that the *Wall Street Journal* sees fit to publish in early 2001.

Courthouse, Diner

Kerouac met his daughter Janet for the first time in 1962 after submitting to a blood test under court orders. She walks away from their first encounter with the cork to a bottle of Harveys Bristol Cream sherry. The blood test was inconclusive, though anyone could see that she looked just like him. He agreed to pay fifty-two dollars a month while insisting the record show that he was not the father, *only that she bears my name*.

Joan will begin a memoir eighteen years later, after being diagnosed with breast cancer. She will write about

her pregnancy and their fights over what should be done, which concluded their marriage. She remembers him insisting that they weren't living in the dark ages, telling her she always thought she could have it both ways and now she had to choose. She laughed at this. She asked him if he was demanding that she simply keep looking after the child in front of her. She reminded him he had been so eager that night that she hadn't had the chance to get her diaphragm from the sock drawer, though she did not go on to tell him that after he fell asleep she had walked over to the typewriter with the scroll in it and started to read what had been written during the preceding hour, about a woman he met on a bus heading to Los Angeles.

He offered her his raincoat as a pillow and was told after a while that she was running away from a husband who beat her, that she had left her son with her parents, who picked grapes for a vineyard. Later Joan will write that there was *always an element of the pathetic, or the downtrodden, or abject poverty and misery* knotted into Jack's inspiration. That she had never let him see such things in her, had never cried in front of him. Jack and the Mexican girl, as he calls her, got to the city and went to a diner where he began to think she was hustling him until they got a fifth of whiskey and a hotel room, where she accused him of being a pimp after he mentioned a six-foot redhead he knew in New York who he was sure could find some work for her. She locked herself in the bathroom and he threw both of her red pumps at the door and told her she might as well

leave, then undressed himself and got into bed. She came out of the bathroom with *sorriness in her eyes. In her simple and funny little mind had been decided the fact that a pimp does not throw a woman's shoes against the door and does not tell her to get out.* So they stayed. The only detail I remembered from first reading this fifteen years ago is the caesarian scar extending to her navel, which he lightly bit. In her memoir, Joan will refer to the woman as Theresa, shortened to Terry, which is also the name she'll be given when the book is published and the name she's given when this excerpt appears in *The Paris Review* and is later included in the 1956 edition of *Best American Short Stories* under the title of "The Mexican Girl," though on the scroll itself her name is Beatrice, then Bea.

On Resolution

Early versions of concrete come into being within and around Rome as early as the late third century BC, around fifty years before the Twelve Tables are first drawn up, establishing a partial foundation for future developments of Roman law. In the municipalities surrounding Mount Vesuvius there is a powder that, when mixed with lime and rubble, naturally produces extraordinary results. Vitruvius explains it this way: *Under these mountains there is hot earth and a large number of springs which would not be there but for the fact that deep down there are enormous fires burning*

because of the presence of sulphur, alum or pitch. In the depths, therefore, the fire and the heat of its flames diffuse themselves through the fissures in the earth and the heat makes the earth there light, and the tufa created there emerges free of moisture. Because the powder, lime, and rubble are all made within the same underlying fire, their rejoining is a kind of recognition. With a little water, they will cohere and quickly stiffen. Masonry piers can be made of this material and placed back into the sea where *neither the waves nor the force of water can dissolve them.*

Sat inside the wall through the winter and read and wrote and coated my hands with newsprint and pressed them together and rubbed to rearrange it into a gray thread. Scribbled the speckle of smudges left on plexiglass *as if someone had been clowning or screaming at its surface for days.* Paraphrased an article on fetal tiger sharks developing teeth before they have eyes, then devouring each other until one remains and waits. On the next page there are notes on individuation. Then *spring arrives and I am struck by a van* while cycling to work. A few days later I'm told not to come back after the weekend because I am being replaced by a camera.

The convoy began in the middle of a Monday on the seventh of July. It began by being slowly unwound around the Ellipse, within view of a Mile Zero, which is a granite pillar level with your chest. The fixed point from which

all distances from the capital have henceforth been measured, dedicated in a ceremony earlier that afternoon; it will briefly support the hand of a beaming Secretary Baker as he lists the feats of motor transport during the Great War and calls the very day they stand inside *the beginning of a new era*. Perhaps this day also includes his passing admiration of sunlight on the bronze compass rose, lifted from the portolan charts of another century, or the way the pillar's line and shadow shifted as he spoke and sought what he sought in such beginnings. And he thought, perhaps sincerely, of the Great War as *a war of movement* and thus declared it to have been so. *Especially*, he said, *in the later stages*. And nearly picturesque to tell. There were things he had seen and things he could say. *There seemed*, he said, *to be a never-ending stream of transports moving along the white roads of France*. Without a bit of pomp and shimmer, a monument is a hobbled, sorry thing. Ike skipped the dedication ceremony and joined them in Frederick, Maryland, after they'd stopped for the night. *My luck*, he said, *was running*.

I came home and began painting an apartment complex, then a split-level ranch, then a hallway downtown. Summer ended. Then fall. Having a parent in real estate and being cheaper than an experienced professional were my combined qualifications. The hallway hadn't gone well. The largest job I ever had, I actually had twice. The first time, I was eighteen and the building was divided into separate

storefronts selling used cars, service uniforms, and baked goods. I had painted the stucco surface a dark shade of pine green over half the summer with a friend while we waited for college. The building stood right next to the long, flat line of the Coralville strip, which stretched a few miles in either direction, toward a cluster of the university's athletic fields to the south and I-80 to the north. We were somewhere near its midpoint. From the roof you could not quite see the interstate's entrance and exit ramps, or the enormous mall that was being built beside them. It would open the next summer, welcoming just over a million customers in its first month. I remember that we also spent two days that summer working together to seal the surrounding parking lot with hot, watery tar and that I nearly retched twice. The second time I painted the same building I was twenty-four and the paint was the color of clay. I was generally slow and worked more or less alone. The stores sold scooters and walkers for the infirm, service uniforms, and plates or portable containers of pan-Asian food. Each time, I think, the pay was the same.

Though eventually such a useful combination of elements will simply be dumped directly into marshland to make it passable for Roman armies.

Jackson Pollock's mother dressed him in clothes she had sewn herself: in gingham and chambray and fine silk pongee. The last of five children and therefore babied. He

wore epaulets, capes, and little coats with large buttons. He liked saying he was from Cody, though the family moved to Phoenix when he was less than a year old, where they were as happy as they would ever be. They tended to some chickens, some cows and goats. There were stray wandering creatures sometimes visible from the windows and there were patches of okra and tomatoes. They grew apricots and sweet potatoes, shucked corn and sliced watermelon. His father made some extra money selling milk to a nearby sanitarium and the children sometimes slept outside in a single brass bed beneath two cottonwood trees.

Tar, thickest among varieties of liquid bitumen, a compression. Understood in opposition to asphalt, which is an ascendance, which emerges from the scentless residue of petroleum oils. A tar gets pulled apart within itself because it is made that way, in a kind of clawing; stickiness and clinging are its preserve because it is the nearly nothing left of macerated wood and vine and coal and bone that were caught and ground down with time.

Roughly the same number of personal ads seeking someone *fun* or *fit* will seek a respondent who is *spontaneous*. Imagine that the present is not a caesura, but a place where you happen through. That you can touch it, push it around. Imagine that you might find someone who acts without thinking, in a way that you might enjoy acting, without thinking. Endlessly stewing about it isn't going

to help. Or something that knows what you want as you begin to want it.

On television, of course, everything is spontaneous. Everything emerges in clear, gleaming outline, exuding its own polish. The defendant dancing on top of a limousine, a contestant's minor glories in montage, a pickup blazing down the highway on its rims. Spontaneity is the interior made manifest—we love this idea—it is your very own moment to throb in real time, a decision that is not a decision, the continued proposition of being like the world; oblivious, performing without regret. It is honesty, nudity, absolute information. A minor rapture at being animated sluff.

Lip curbs were first added to Iowa roads in the twenties, as a way to control drainage on hills and inclines. Opposing-lane highways arch almost imperceptibly toward their central dividing line. They empty rainwater into a foot-wide crevice at the outer edge of a road that will be framed by an ongoing lip curb on either side. The downhill channels were designed to spare easily eroded shoulders of gravel and dirt. The decade passed and the average width of a vehicle continued to swell. And so it will increasingly come to be the case that a wheel is running through a stream of thick cascading water, slush, or mud, then grazing or pushing onto or over the curb, then swerving onto the well-preserved shoulder or ripping a tire off or breaking an axle or careening back onto and across the road and into a lane of oncoming traffic.

•

Somehow sensing that it might already be late enough to rise and make for the facing shelf to admire *my prose so blackly neatly typed on onionskin whitepaper & bound in my blackbinder* beside a small nightlamp. Or he waits to write or think and simply touches it, then asks again that question that invariably makes him feel alone and special—*why am I alive?*—somehow specific and generic, but mostly very lonely, like a half-lit service station after dusk on Thanksgiving. Then he will repeat it and put his fingers in his pocket for a cigarette, as if it were his question to repeat again for its jubilant tang, for the sense or feeling of needing to feel almost dead, though not exactly, with his fingers in his pocket or in front of him and he is or is not drunk or high as he sits to write of reading not himself but the other being he perceived there, the one that lets him say his life or its claims, as he claims to see it there: whirling, anxious, balletic. This life, he writes, has been preserved and *made into something more important than myself in other words an angel has made a record of it & in original language of the angels for the angels, pure, mono phylactic private murmuring intonated long song of life I have here created---my shelf of prose* which is not a slow-growing tumulus but a platform upon which is enacted again and again *a great ballet of myself a drama of myself---with the background drapes not a stagehand's work but the color of time and rain itself* and so it does not matter if it is his question, his pocket, or his fantasy. Or if it is ours. Since

somehow, at this moment, understanding and audience are one. At least they were for him. And it is like that for a night, maybe. It is 1953 and mostly nobody knows who the hell he is.

Though the first president who sought to describe the sensation of being carried alone by a speeding automobile was not Ike, but William Howard Taft. *Atmospheric champagne.*

My friend and I worked slowly that summer, talking a little about college, reapplying sunscreen and pulling paint across the building as four lanes of traffic flowed and clumped along the strip. We lingered in front of one another's televisions in the morning and took long lunches out of the heat. We quit early whenever one of us had another obligation in the afternoon because we had come in one car, usually his. Once, in the middle of an argument, he told me that there were things I could not understand because I was the son of a rich man, a comment I resented. He knew nothing about the debt my father was then still paying off, though I knew little more than that. I knew he had gone in on one branch of a bar-cum-laundromat chain somewhere in the Quad Cities. That his own father and my then-uncle were his partners. That the latter declared bankruptcy soon after the business went under, and that my father took on the payments for the three of them rather than doing the same. This was something he almost never spoke to me about until we had

to fill out forms petitioning for the financial aid I would eventually receive to attend college. I did not really know what I was entitled to, but I was given more than expected and decided to be grateful. I'm pretty sure I said none of this to my friend. But I knew my father had money. I knew there were things I couldn't understand. Like why it felt so unswervingly appropriate to leave for college in the first place, or what it would feel like to be unable to afford the best school you had gotten into, as my father's parents were unable to afford Dartmouth. Or what years of quietly scraping away at a debt might do to you.

They arrived to clambakes and parades, watched magicians and boxing matches, sent up flares and signal rockets from the corner of Third and Main. Picked up a stray bulldog, a rooster, and a raccoon and kept them as mascots because fuck it. Let the searchlight play across the night sky like a question. What is a war without a costume drama, to you? What is speaking when memory is dead? Who is this huckster taking the stage, claiming to be *the original chanticleer*? They replaced spark plugs and clutch disks and stuck the fender back on the trailmobile kitchen again, and received chocolate and cigarettes from the hands of young women in Ohio. And in another forty years the road's boosters will be printing up pamphlets entitled *Your Rights and Benefits as a Highway Displacee*. On the first panel there will be a simple line drawing of a simple nuclear family. White, with suitcases, leaving home.

We don't see an object in the distance because there is no distance, only a flat, undifferentiated green to be walked into. Presumably, it is the future; thin, underripe, wrapped in cash.

The beauty of Jack is inseparable from his ability to appear so irretrievably wounded and self-involved. To be iconic, one foot beside a running board and crouching. To be perched on a fire escape, pulling on a cigarette at midday. He looks so effortless. Aquiline in his slump. Or, in an undated photograph, posing behind the large pelvic bones of some fine animal whose remains lay in proximity to a campfire. Raised to his face, the holes become eyelets opening out to either side of the long matte ridge below his bald pate.

Ike later described the convoy's personnel as *literally thrown together* with *little discernible control.* They *colored the air with expressions in starting and stopping that indicated a longer association with teams of horses than with internal combustion engines.*

And we sat in the cab of his truck driving east and he said, *The people who were protesting your parents' house—I don't know what you'd say about them. You know one got in and defecated right on the floor? We'd just put the carpet down. And stuck a little green flag in it. I bet he didn't tell you that. I guess I think they're animals,* he said.

•

The way certain emotions made him less human, more a type or alphabet of functions and signals—i.e., yowling, spitting, staining things with sweat.

Nobody standing around the scroll brings up the second mention of Iowa. It happens in passing, near the end of the book: *and all that road going, all the people dreaming in the immensity of it, and in Iowa I know by now the children must be crying in the land where they let the children cry . . .* though on the scroll itself, the line is simply not there. The end is a jagged rip, with a penciled note on the underside: *A dog ate*. Pollock's *Mural* is also said to be snipped—eight inches from one side. A story attached to this claim has Duchamp making the cut and declaring that in this kind of painting *it makes no difference*. Later studies of the canvas can say what they want. A myth has no need of artifacts. The belief that something is missing benefits each object by allowing both to stretch beyond themselves, eluding conclusion, further spurring our adoring intimidation.

1948. After almost half of the state's paved highways have been outfitted with lip curbs the Iowa State Highway Commission will determine that the benefits are not worth the hazard. The pavement-breaker they send away for is manufactured in Los Angeles and designed to be operated upright, like a jackhammer. It performs its title with a single air-compressed two-hundred-and-sixty-pound steel

piston that is four feet long and six inches in diameter. Since there is no existing instrument made specifically for the destruction of lip curbs, ISHC officials will lay the breaker on its side and attach it to a mount designed specifically to cradle it. They will bolt this mount into the bed of a truck. They will angle the piston's head into the side of the ongoing curbs that line the roads that the truck will slowly roll across while the men supporting the mount in the bed of the pickup set about reducing the highway's edge to rubble and dust.

Classroom, Dining Hall, Stadium

1913. Ike has begun to thrive at West Point, pursuing a fledgling interest in tanks. He has just ended his stint as a football star, having moved up to the varsity squad during the previous fall, eventually appearing in a season preview for the paper of record, photographed in mid-punt beside a column of text declaring him *one of the most promising backs in Eastern football*. He twisted his knee in a game against Tufts and watched the swelling come down a little in the hospital before tearing the hell out of it three days later trying to dismount a galloping horse in

the riding hall. Trick they called the monkey drill. He was informed that he would not play again and hobbled sourly around campus into the next fall. He grouses in his letters to Mamie that she would not recognize him now, he has grown so gloomy, that he hates feeling so *helpless and worthless . . . the only bright spot is, just now, that trouble with Mexico seems imminent. We may stir up a little excitement yet, let's hope so, at least.* Ike's anticipation was not entirely misplaced, though it will not be the army but the U.S. navy that will invade and occupy Veracruz during the following spring, with extensive civilian casualties. This was the culmination of a protracted U.S. standoff with Mexican president Victoriano Huerta, who will be forced to resign by the middle of the summer. Huerta, who came to power after a coup facilitated by Henry Lane Wilson, the U.S. ambassador. Protests in Mexico City after the fall of Veracruz will include a donkey, whose swishing tail will be tied to an American flag that will swab the streets surrounding the capital's central plaza. Unlike his elected predecessor Francisco Madero, Huerta will not be shot. Two days after Ike describes his uncharacteristic moping, he will write another letter, in the fresh afterglow of Army defeating Navy by nearly two touchdowns while Ike stands and hollers among the forty-five thousand fans in bleachers, rapturous: *Course I couldn't raise a riot for I was in uniform—but I went down to Murray's in a crowd of four— and we danced and ate . . . the joy of the thing is too much—I feel my reason toppling.*

This is the year that Henry Joy will be named the first president of the Lincoln Highway Association. Joy, who three summers before had spent a few months traveling across the country in an automobile produced by the Packard Motor Car Company, which he was also the president of. He began in Michigan and got as far as Omaha before seeking out a local Packard dealer to help him find a continuation of the westbound road. He followed the dealer's car to the edge of town, where it stopped in front of a long stretch of wire fencing. The dealer walks to the far end, unhinges the fence and holds it like a bedsheet, upper edges pinched between his thumb and forefinger. He says that from here you just keep driving and Henry Joy shakes

the hand he offers and eases on to the next fence, which he will unhinge and replace himself, like a gate, and this goes on until there are no more wire fences because there are no yards or fields. Two ruts are running across the prairie and he will hold to them. There are no patches of gravel or ditches or any particular indication of direction aside from the movement of the sun and the incised surface of the slow-rising hills overgrown with grasses and seething in the wind, and the comparison that occurred to him was one common to eyes that had already advanced across such spaces, and it was to water: its sheen and weaving, its way of seeming ceaseless and blithe and almost impossible to imagine any end to. Imagine him stopping for a single view within a surrounding that looked like it could be anywhere. That could be called almost anything he wanted.

What Is a Passenger

1934. Thomas Hart Benton openly preferred students from anywhere other than the East Coast. Pollock appeased him by having been born in Wyoming and moving *like a heavy, lumbering bear*. A few months after enrolling in Benton's class at the Art Students League, Jack was being invited over for Sunday dinners with the family. Soon afterward he was asked to babysit their first child. Jack sat in class and listened to Benton talk about hollows and bumps and what made Michelangelo and El Greco so great, and the interplay of swelling and

recession in depictions of individual laboring bodies as they appeared upon the picture plane. In the afterglow of a meal Jack sat and listened to Benton recall the sketching trips he took whenever he could because it was essential to go roving out into the land to collect local color and also they were a great time. In the summer after his first year at the League, Jack will follow suit with a classmate named Manuel Tolegian. They had known each other since they were students together at the Manual Arts High School in Los Angeles, where Jack often struggled to make friends, and though Tolegian was not quick enough to run down a departing train in Indianapolis, Jack was and so continued on without him. No hard feelings—the next summer they will work in the Angeles National Forest clearing brush and cutting down trees for a planned road. Early one evening Tolegian is driving Jack down San Gabriel Mountain and mentions that he thinks Jack is crap with the dragsaw, pulling when he should be pushing and pushing when he should be pulling, and then a handsaw is picked up from the car floor and raised to Tolegian's throat, tipping his chin back a little and a little more until he tries to push it away with one of his own hands, the other now holding the wheel just well enough to total the car, which swerves into the mountainside.

Not one of Jack's sketchbooks from before 1933 has survived, but a consistent element in his early regionalist landscapes is the way they routinely approach complete evacuation. Often one figure, a hat, a horse or mule.

I quit the highway in southern Kansas and grabbed a freight—went through Oklahoma and the Panhandle of Texas—met a lot of interesting bums—cut-throats and the average American looking for work—the freights are full, men going west men going east and as many going north and south a million of them. Jack enjoyed hyperboles as much as the next traveler, but this particular figure, written into one of his postcards, was probably a low guess. In the coming year the Southern Pacific Railroad Company will estimate that over seven hundred and eighty thousand people were apprehended and ejected from their passenger and freight cars, while other companies simply stopped counting. I run across this figure in *Furious Improvisation*, a book centered largely around the history of arts funding within the Works Progress Administration. It opens with a two-day train ride from Washington, D.C., to Iowa City, which gives Harry Hopkins and Hallie Flannagan time to talk. Hopkins works mostly with Federal One, which funds a grab-bag of visual, writing, historical, and musical projects, while Flannagan is the newly appointed director of the Federal Theatre Project. They graduated a year apart at Grinnell College, located in the town of the same name, where Flannagan had grown up. Hopkins had been born nearby, in Sioux City. The WPA has been up and running for three months and the recently coined word *boondoggle* is now coming into more frequent use in the *Des Moines Register* and elsewhere to describe the program's make-work projects. As the train they sit upon works its

67

way into the Midwest, Hopkins is continuing to explain to Flannagan that every choice you make will be attacked, that every project is always called a cheap mess or a waste of money and that he's more than expecting to be run out of town in a few months, but also that this helps to clarify one's priorities. When Flannagan writes later about her first rally, she will remember that *it was a hot night and the farmers were in their shirtsleeves*. The *Register* will characterize Hopkins's speech as *slangy and plugged with wisecracks* though mostly it went over as well as his ad-libbing, as when someone in the crowd shouts out *Who's going to pay for all that?* and he lets the sound of it hang there while he takes off his coat and rolls up his sleeves. Such gestures, with time, or when staged, seem to have no reference to weather. As they become synonymous with an assurance of no-bullshit-here-folks, or as we became accustomed, with each caucus and our window of relevance, to the impossibility of knowing if he meant it or how it sounded when he looked out to the crowd and said, *You are*. And asked: *Who better? Who can better afford to pay for it? Look at this great university. Look at these fields, these forests and rivers. This is America, the richest country in the world. We can afford to pay for anything we want. And we want a decent life for all the people of this country. And we are going to pay for it.*

Ozone Park, 1943

Kerouac sat in his room looking through pioneer histories and repeating names like *Platte* and *Cimarron* back to himself because he liked the way they sounded. He unfolded maps across his unmade bed and repeated other names aloud and eventually he packed them into his knapsack between socks and a checkered shirt. He would take Route Six all the way. Days ago he had decided this. Then he waited; thought perhaps of ancient Chinese maps that took the form of rhymed recitations, to be memorized and reeled off as one walked or trundled toward wherever; or

he thought of the route-books that had preceded fold-out road maps in the states, the route-books that were all page-flipping and synecdoche, mostly photographs of any landmark where you could be told to turn or continue forward. Probably he thought about none of these things. He left a note for his mother and locked the door to the apartment his parents had recently moved into, then walked down the stairs and out the door and around the corner past the drugstore they lived above, then to the subway that he took to 242nd Street. He took a trolley to Yonkers, then another to its outskirts at the east bank of the Hudson that slid past quick and slate-gray beneath the dimming sky. He hitched five rides north to Bear Mountain, where Route Six cut across the river upon what had once been the largest suspension bridge in the world. He stood beneath a tree. Cascading rain ran through the branches and leaves and soaked him as he watched the nearly empty road for an hour and started swearing and crying and socking himself in the head. He ran a quarter-mile to a filling station where they said mostly freight didn't come through this way anymore and maybe try Pittsburgh. He finally got a ride to Newburgh and took a bus back to the city.

Return and Departure

In the summer before he takes his sketching trip, Jackson will visit Pomona College to see José Clemente Orozco's *Prometheus*, a mural twenty-five feet tall and thirty-five feet across at its widest point. It is situated above a large fireplace at the far end of the school's primary dining hall. The plasterboard Orozco painted on was infused with cotton to better absorb the sound of clinking and clattering silverware and trays, the refracted conversations piling up and draining away from the echoing room.

The legs of Orozco's hero form a near-perfect right triangle, one of them ending at the knee, the other extended

to the left, across jagged glowing stone. His head is tilted to the side, nearly flat upon his shoulder. Poised above his face and just below the peak of the arch are his hands, which disappear into vaporous orange flames. There are visages of little people in crowds at either side of him, faces a near-uniform color of ash. The cold in them is like something clotted on a screen, unable to crystallize. José Pijoán, who helped initiate the commission of the piece, will write that this Prometheus is not an *ancient floorwalker easily handling a torch.* In his autobiography, Orozco will mention that he had managed to keep to his plan of going to New York after completing the work, even though his commission wasn't enough to cover the ticket. Jack will later call this the single greatest painting in North America. He will make this claim, off and on, for more than a decade.

1946. After a demonstration of cement-based construction in an unnamed town or city, Iowa State Highway Commission employees Rudy Schroder, Willis Elbert, and James Johnson gather and chat at a diner. Most of the roads in Iowa are still dirt or macadam. This year is the first in which a full-color film adaptation of Shakespeare is screened in the United States. Harry Truman will sign the Atomic Energy Act on the first day of August. The most common method of laying concrete roads is rooted in straightforward, incremental geometry. A mixer chute is lowered onto a leveled square of dirt, gravel, or loam, then framed with wooden planks and steel stakes. After

this form is filled, the wet surface will be graded and left to set and it will go on that way, each beside the next, so that the road will grow in the pattern of an oversized sidewalk. Johnson has decided that another approach will begin with the mix itself, which can be strengthened by increasing the ratio of cement to water, giving it a consistency more like mashed potatoes than gravy. Make it firm enough to be self-supporting when wet, and it becomes possible for the surrounding frame to keep moving forward, this open-ended frame now being attached to a wheeled machine laying and grading the pavement while sliding steadily on, vibrating the mix into place. Make something new, you get to name it: they decided to name it *slipform*.

I remember that in college we often sat with no one else, A. and I. In our picturesque campus dining hall or on the second floor of the library or near the end of an aisle of cushioned folding chairs at a lecture; that we did not think it was sad or overly insulating to simply share the end of one table and appear at a glance to be nearly friendless. It is impossible to imagine doing this any earlier in my life. The cafeteria of my junior high had a well-enforced, eight-to-a-side policy for every table, which meant that if some-one more well-liked than yourself showed up late for lunch it was almost always amazingly easy for a consensus to be reached as to who should leave to make space. I tell myself that obviously this is petty to hold on to and must have happened to almost everyone, or at least to anyone overly

determined to punch above his weight within the social tiers of lunchroom table arrangements. What came to amaze me was not how important these moments had felt, but that when I was nineteen a girl told me that she loved me. I remember it was winter and we were shuffling across the main path through campus, which was gravel and ice lined with lit filaments, a thin orange sheen on refrozen snow. We were coming back from a party, though we would almost never go to parties for the next five years, and we sang a little to each other half-seriously. I remember that it was fun to be both horned-out and mawkish. We made ourselves a refuge. We curled into one another and slept. People wandered past your ground-floor window. What I meant to say was thank you. It is easy for the life of a college to feel like chatter behind smudged glass. To decide the world is loud, driveling, almost entirely pointless and in no way as interesting as you were to me. Thank you. Living again in such a town, I find I'm accustomed. I don't think we cared how boring we probably seemed to almost everyone. Thank you. Didn't care if these were probably our best years to really sleep around. I still think you were interesting. What made us want a term for finally-I-found-someone-to-be-lonely-with? If you ever proposed one, I forgot what it was. I liked knowing that you were smarter than I was, but it made me nervous to bore you.

Here is an arrangement of flanks and shadows. Here is the looming nude titan purloining one gift for the slaver-

ing gray horde. At an angle to the enormous right hip of Orozco's Prometheus, the crowd that assembles outward in a clustering line is led by two figures. They have their backs to us, one sinking, one extending his right arm in a sweeping gesture. Above his shoulder we can see the profile of one bowed head, each behind it growing more obscure, a series of rounded, ashen scalps, each curved line marking where the next begins by becoming now more and more tightly inlaid upon what follows.

Dear Jack,
 I went from restaurant to restaurant to collect different versions & from the News & Examiner got the largest clippings.

Robert Brady, a painter Peggy met in Venice, later contends that the reason *Mural* ended up in Iowa City boils down to the untimely death of Peggy's younger sister and the distribution of the mail. Benita Guggenheim died in 1927, eight years after marrying Edward B. Mayer, whose father was then our town's postmaster, which was why Peggy always felt a particular tenderness for the place. This explanation, later taken up by the University of Iowa Museum of Art, is as close as we will come to saying that we have no real idea why this painting ended up here. That there is really no clear reason why I can spend part of an afternoon alternately staring at it from a swiveling chair and walking toward it until the surface is four

inches from my face, then stepping gradually back until I find the point at which the painting presses into the edges of what I can see. I did this because my teacher told me to, and because I had read somewhere that humans generally remain unaware of their peripheral vision unless under attack. I tell myself that this may be why staring at *Mural* can put me into a muted panic. Also, that the narrow width of Peggy's hallway would have made this exercise impossible.

In notes for an essay on Rimbaud, perhaps for the *silly New School* as he described it, Jack says his entire life boils down to two scenes: in the second we have the prototypically wrecked *poète maudit,* head-down on his mother's kitchen table, weeping *for what has happened, for Verlaine, his family, everything.* In the first, we are given the young seer, enraptured, sitting at the same table like a little god. The intervening space will be covered by Jack's unwritten essay. In it, he planned to contend something like the following: 1. Every creative act is a matter of facing up to your maker. 2. Rimbaud did not realize this. And what if any line is only this following? If a single set of bookends was and is all you ever get? I and thou, it and him, made and manufacturer; these forms arriving with the mail. Would you try to send them back?

Was this what writing was destined to be—an endless report on what one had done the night before while listing the names

of the all-alike towns that one sped through on the ever-same road? It is not easy to choose among the derisive questions Gore Vidal had for the Beats, and for Kerouac in particular. They met twice in 1953, five years after the publication of Vidal's first novel, while Jack was living in the odd interim between the completion of his best work and the onset of fame—i.e., he was sometimes brazenly questioning, proceeding by modes unknown, frantic though not yet desperate, taking a day and a day and then another to write another book, for example. When *The Subterraneans* is published five years later Jack renames Vidal and offers a version of their second encounter in which he repeatedly kisses the hand of Arial Lavalina between drinks, then goes back to his suite at some hotel and wakes up there late the next morning, on the couch.

When they checked in at the Chelsea Hotel they signed their names into the register and Vidal remembers telling the clerk that this would eventually make it famous. Then that they went upstairs where Jack blew him, was on bottom, and maybe slept on the bathroom floor. In the morning Jack needs money for the subway. He is given a dollar, then told, *Now you owe me a dollar.*

1935. Pollock will first be assigned to the Project's mural division, where he works exclusively as an assistant before being transferred to the more prestigious easel division. If it seems pig-headed or inept to us now, reading of Jack or Claes Oldenburg or Mark Rothko being compensated

only after completing a required quota of work—if we struggle to understand that they were then, essentially, painters being paid by the inch—it is largely because we have difficulty remembering that this project had no real interest in making anybody a star. Holger Cahill, the Federal Art Project's primary curator, could summarize a position succinctly: *Art is not a matter of rare, occasional masterpieces.*

Production requirements and check-in policies never stopped being a problem for Jack, who turns up in anecdotes from various histories of the era and its undertakings, usually sprinting from the subway in his pajamas with that month's still-wet canvas or dragging ass into the main office to punch a time clock in his bathrobe before turning back toward the door. What he was painting was largely forgettable, but it allowed him to eat. The repeated push to finish a requisite canvas also seems to have been the only time he allowed himself to drink while working.

In the year before Mackinder presents his paper, New Mexico will become the first state beyond the Mason-Dixon Line to document the use of prison labor in the maintenance and development of roads, a practice that will grow more widespread as the century continues.

If I were to name the colors of *Mural* as I see them, I would write: *black, bright red, gunmetal, lemon, putty, blue, stale fog.*

•

The Royal Road of Persia is laid across three mountain ranges, lined with artificial oases at which relays of horses were kept shaded and fresh so that the couriers of Darius might cross Asia Minor in nine days instead of three months.

They were early to the little party and came in through the fire escape window. Later Jan went back out alone and looked at the starless night sky and thought about her life. Jack was inside, clarifying things, naming debts. She thought of her grandfather, then let herself look at the long rows of streetlights, white and squinting, like spiderwebs. Jack maintained that Celine did not hate women but that he knew what they were.

2008. The colors as seen or overheard. As *you cannot pile it on that way*. As *that's no way to hedge against a life*. It was spring, not fall, and I thought again about the silence of his painting while I stood there breathing, then about the impossible sounds of four rooms inside a house I have never been to, made by people I did not know. Even putting them—my thoughts, I suppose, or this association, this overlay—in the same room with the painting made me thick with shame. To claim them as thoughts, as some kind of *insight*.

His citation of a survey in which reported levels of happiness peak between 1943 and 1956.

•

Figure, ground, or act. Or a language that pretends these are separable, divisible, uninterrupted by the verbs that course through them: *swelling, corroding, catching* or *caught, bludgeoned*. This insistence you depict, if not the man, then the victim, if not the victim then the permission given, imagined, self to self; if you have imagined or decided in advance to destroy yourself, if he did. If not permission then injunction's *someone*. Someone must be lit, remembering, contracting, making decisions for the one and the many, unafraid to stand and extend, to be so flush and depended upon.

The indiscriminate violence of a god and its suspension. To be not yet ripped open and not yet a mineral and nearly to hear them as they beseech you.

They're children, he said. *Just big, beautiful children is all. And no more inferior than children*, he said. *And I love them.*

2008. The call came as I crossed the street, craning my neck left, then right, convinced that the van would appear as it was described to me, though by then he was already on the highway.

Askesis or curtailment. The claim it made: to patch the rent.

Even after repeated viewings, *Mural* retains a kind of overbearing anticipation. It is difficult to remember that it

will be another four years before he begins the drip paintings. We can know this and still forget, without any effort beyond holding the painting with our eyes, or being held by it, on a precipice and tipping.

Perhaps we revel, in part, at what it is not yet doing. We seek or see a body still bound to a surface that both receives and resists any impulse to raise an arm away from it. It may be that we like to know that its hold upon him will not be overcome. That we see a thing that cannot know about itself what we know of what it will come to. If it is nearly impossible not to think of the approaching moment when a hold upon his own mark-making arm, stick, or bristle will be broken, or if this moment is magnified and generalized through the mist of what is oncoming, perhaps it is only fair to ask how it seeks *something of the past*, a wistful title Jack opted for elsewhere.

Fifty-six by thirty-eight inches, lot number twenty-two; sold for two million, four hundred and twenty-two thousand, five hundred dollars on the eighth day of May, nineteen hundred and ninety six, almost exactly a half-century after its composition. Half of our state's topsoil has disappeared in the interim. Oil on canvas, signed.

1953. In late April Ike signs an executive order mandating the dismissal of any and all federal employees on the grounds of sexual perversion.

•

That Jack's relationship to color oscillated between incomprehension and hysteria, hysteria and habit. We sought swatches for corrections: *March Wind, Coral Bay, Samovar, Indian Bluff, Casava Barleycorn, Sea Pearl, Duckling, Whitecap Gray*.

We invested in a mud pump and a series of sieves. We arranged liners and valves. The loess hills disclosed themselves as repositories of the road. We attached a swiveling metal arm and painting wheel to a surplus truck from the Great War to make it mark our broken and unbroken center-lines.

A relation proceeding by means of each detour, *per via*: pale blue shards in the beach sand beside the ruined counting-house, separated out across a sequence of tables. They are rendered to the sea after reconstituting any part of the Roman mural they once were is deemed impossible. *I think a painting dies, you understand. After forty or fifty years*, Duchamp will insist.

Within the painting there is the barest sense of something creaturely, or an attempt to imagine that there could be a creature before there is a number. That such a point is something we could be allowed to see. Before it has teeth or feet, a spine or claws or none, digits, a tail, a fin or none. Before it can be driven out, enslaved, made barren or mature. Before it can be solitary. If a pack of stampeding animals becomes

wondrous and terrifying by refusing any sense of singularity or figure, *Mural* is asking further into this confusion. The years immediately surrounding the painting are cluttered with reworkings and contortions of the totemic and arcane. They are permeated with what one critic called *the whiff of primal hordes*. *Mural* comes alive by doing less, refusing to let any particular shape emerge as skull, teat, or butchery, refusing to let any outline become a loaded fleck of primordial significance; evoking, somehow, something even more impossibly nebulous, churning toward no obvious outcome, refusing again and again to say what is primary and what is stagecraft. As a theater-piece, it could be called *Dreams of an Undifferentiated Animal*. Lugubrious titles became tiresome to Jack, for a while. He could have called it *One, 1943*.

In October 1950 Jack divided a page into two columns under a masthead that read *American Times* and he gave the first and only story in his newspaper the title "On the Road." A few pages are filled this way. He sketches and resketches scenes into notebooks or onto scraps of paper. He writes a line or two or several. He sets about beginning and abandoning story after story. A sentimental man named Ernest Boncoeur has dinner with an old friend writing copy for the sports pages of a San Francisco newspaper. A child is transfixed by a glinting brass banister on the dark mahogany bar where he and his uncle have listened to Ezzard Charles defeat Joe Louis on the radio. A cousin named Napoleon is convinced that the world is rotten. A

cook wakes up in a Des Moines boardinghouse. A west-bound stagecoach stops beside the brown Platte River and a man steps out for a smoke while the driver waters the horses. We are carried by an angel over the rooftops of a city in the pit of the night.

Jack gets distracted from the story, attempting instead to explain what he means by a word, to say that the routes running west have always been the same, that engineers have only fattened and paved the paths *established by Indians, worn by white hunters, and developed by early pioneers searching for the inevitable land of gold at the world's last shore.* The road is this singularity, *the grand, prime symbol of* ~~*universal history*~~ *the world, that leads from the tip of Cape Cod where the Pilgrims sighted the New World land for the first time to the Pacific Coast.* This draft goes on a little while longer and is set aside. He mentions in letters that he's always struggled with plot and dialogue, his strength lying more in scene and atmosphere, in solitary eyes describing the feel of things. Jack manages mostly without the use of quotations. He reminds himself constantly that words must go and go and go. He also liked to talk about what was unwritten, envisioning, in the midst of letters and conversations, a book that could act as a single surface and what he would catch upon it; the refrains of every warbling jukebox, every weathered wooden board and sad-eyed bum, every trestled bridge and near-empty diner, and whatever thread might hold them together. What was it that he was trying to name before he could get a story going? He may or may

not have found it any help to have begun by saying that the first term recorded on this continent for such a particular, billowing space, or object, or idea, was not *road* but *ohtli*. That it can be found among the volumes of Nahuatl words copied onto paper by the hand of Bernardino de Sahagún and later organized into *A General History of the Things of New Spain*. With the help of three native understudies, he spent about half of the sixteenth century compiling an enormous sourcebook, sitting or standing before small groups of Aztec men from the upper strata of a disappearing civilization, trying to get down everything they tell him. He transcribes their adages, definitions and myths, their explanations of social stations, of weather, history, and the natural world. A road is rarely one thing. If it is wide, almost a highway, it is called *ochpantli*. *Ohzolli* if it is old, *nicochphana* if I am sweeping it, *ohmati* if it is a known thing, *otentli* if we seek to name its edge. Among what is spoken and written down, arranged into entries, translated into Spanish and later into English, there is still another to be named: *Its name is secret road, the one which few people know, which not all people are aware of, which few people go along. It is good, fine; a good place, a fine place. It is where one is harmed, a place of harm. It is known as a safe place; it is a difficult place, a dangerous place. One is frightened. It is a place of fear.*

There are trees, crags, gorges, rivers, precipitous places, places of precipitous land, various places of precipitous land, various precipitous places, gorges, various gorges. It is a place of

wild animals, a place of wild beasts, full of wild beasts. It is a place where one is put to death by stealth; a place where one is put to death in the jaws of the wild beasts of the land of the dead.

I take the secret road. I follow along, I encounter the secret road. He goes following along, he goes joining that which is bad, the corner, the darkness, the secret road. He goes to seek, to find, that which is bad.

New York Public Library, Third Floor

1909. In late January the Automobil-Verkehrs- und Übungsstrasse is founded in Berlin. A track consisting of two lanes, each eight meters wide with a nine-meter median strip, was funded not by the government but almost exclusively by a combination of financial and racing organizations. Within three years they will begin the construction of a nearly ten-kilometer road that is significant for being completely devoid of intersections. It begins near a former railroad line and ends near the Teltow Canal in Charlottenburg. If Gertrude Stein is writing

on that day in her Paris apartment, she is as likely to be working on a prose piece from that year entitled "Men" as anything else. If they were sometimes smiling, despite the cold, then she may have been writing that sometimes *men are drinking and loving and one of them is talking and two of them are fighting and one of the two of them is winning enough so that they are then having loving in them and are telling each other everything.* People said she would often take out a notebook, even when entertaining guests, and go about filling it while they chatted, as they were perhaps chatting on that day, in this place if not another, and this chatting could become a chiasmus, wrought into a sweep somehow both pliant and stalwart in its progress, as he was when he *was one sometimes knocking some one down and being then falling down something and being then one having been knowing something. He was then when was knocked down by the one he could have knocked down he was then loving and kissing and they were then knowing everything. He was such a one and was one having been having meaning in being one being such a one.* And in Berlin there were perhaps contracts being drawn up or redrawn by parties relevant to the track consisting of two eight-meter lanes and a median strip. It is nineteen years before anyone will use the term *autobahn* and it is also almost exactly a century before Lisa Robertson will move from Vancouver to Jouhet, a village three hours south of Paris, where she will reside during the publication of a book with a title nearly identical to Stein's, one that will include a string of words that read: *When a man rides with*

a demon, when he transmits and snags, when a man feels his psyche work all over america in its humble way, when he has no obligation, when he marches on, when a man marches on, when he has hideous knowledge and he marches with it in the burnt grass, when men believed so many things, when a man's name is sewn in the label of my coat, when the men's cocks face out to sea, lovely // And I thank them.

Departure and Return

He began *Kim was a Western Girl*. He began *Ben Baloon rose from his sickbed & decided to live again*. He began *This is the confession of Earl Chadwick Gavin* and *Finally handsome Eddy dim and pale from many jails*. He made lists of characters and relations. He crossed out the last name *Orangeblossom*. He began *This is the confession of Earl John Moultrie*. He began *At first I thought the Americans weren't going to make it. Do you know what I'm talking about?* He crossed out *roar of* and *the tragedy of*. He listed a few words in Joual, a Quebecois version of French that he first spoke

at home: *Paddock, Romage, Ronyon*. He began *Ain't nobody never loved me like I love myself, except my mother and she's dead*. He named characters Clem Paradise and Dorie Jordan. He began *Saturday night in America*.

The elementary logic of the dream wherein a shambling figure in the headlights cannot be caught up to; an explanation of the overlaps as their own counting system.

As formula or as claims, as straining: not capacious and faux-Latinate but folds that wrap the hackneyed. Not *mono phylactic* but stymied and plied, intersentential.

Fidgeting, whistling, distracted by the limbic system.

Nothing, wrote Herodotus, *could be faster than these couriers*.

A seam of his prolix inertia. *Jack's been hungup making apple pies all week* said Neal to the microphone. Three in two days, as was writ. *You gotta stare*, Jack said, *to really listen*.

Dear Jack,
 I have taken from you and re-interpreted for me. Perhaps that is not pure—too bad. On the other hand I find it impossible to stand back and say "Jackson can do better" or "This is marvelous." Someone else will have to judge, preferably you. For can I speak to you in the language of

artists, as I am not one myself. I can only look at your work
as a layman, feel as a layman—but one, Jackson, who is
interested and cares to see it.

Further prospects. To stare and stare out of car windows, attention burnt to a nub. Abstraction as it learns to doubt itself. Emergence of a manual, as when a humming oval makes itself a line, as if tilted. Tamping, compaction; writ in Rome, read in Alexandria.

2007. I went to the city and walked into the very famous museum a half-hour into the free evening offered weekly and then into the room filled with only his work and began to transcribe everything I could overhear anybody saying though what I wanted most to hear and so wrote was that *we come here to forget the names of things.*

The country's first pedestrian traffic casualty is recorded in New York City during the final year of the nineteenth century. His name was H. H. Bliss. According to the paper of record he was struck after *alighting from a south-bound Eighth Avenue trolley car.*

If the impulse or idea of seeking something alive and coursing beneath a surface or crust of the city or the earth was not in the least unique to Jack, at least his title was. His choice, with *The Subterraneans*, to make an adjective into a plural noun was not only a claim to see what was

hidden, but to say he would name it with new language, if not of angels, then distortion. Thus they are not spaces, not qualifications, but figures to be named, then renamed. Bodies he sought. Touched. Hesitated toward or mistook or pushed into sight to show his own outline. Problems, of course, but also solutions. Because even if he found part of his desire disgusting, this did not mean he could not simply begin again, choosing a more comfortable edge to write toward. And so made a book about his brief romance with a woman who was black and half-Cherokee and very, very sad, or so he said, and he gave her the name of Mardou Fox. Because it was neither Arial nor Ariel who would sustain his eyes or serve his book and it felt natural enough to begin by making a figure inextricable from atmosphere, to show her leaning on the curve of a fender, on Montgomery Street, at night. *So dark,* he said, *you could barely see her in the dim light.* And probably it cannot surprise us that he would see or need this way, beside his selfsame eyes. He went on to describe hers as *intense* in their staring, but also *little, honest, glittering.* The nick of the invisible within the visible. Surely he saw that, even if he could not say it. And maybe we are not interested in accusations or excuses, or the unfailing premium placed on surprise. Because it also should not surprise you that when his book becomes a screenplay and a film, this figure will return, remade pale and French. What will be changed by typing one name: *Alene*; or appointing yourself to that task? By insisting on *other* as a verb of pursuit? The one that took him to those

93

jazz clubs, where he sat beside her. The texture he made by tapping the table adjacent to the stage not afeared of finding no word like that or that or that one. Beside the compulsion to repeat there was another: a dream of limitless disarticulation seen or verged upon, wherein the present attacks the voice like a thousand twangling instruments and yet the voice is saved. To be somehow a conflagration and its remnant. Summoned, tucked. *And so I shall have my music for nothing* is one kind of fantasy. Erasure, another. And if he was specific in saying that the face inhering to hers was not his sister's but her friend's, who is named Rita Savage. And he used to imagine her blowing him in the bathroom stall, he says: *with her special cool lips and Indian-like hard high soft cheek bones*. These claims to memory and pleasure are unapologetic. Because the thing about Jack is, he takes what he takes. The problem with theft is that it may never end. If the condition of my speaking or this writing is that I was given, in my own way, a loaded kind of language and have also learned to curse, it will never sound the same coming from my mouth. For example, to say I read him and thought of you locking the study carrel door behind us, sitting me on the desk. To say I read him and regretted being straight. Or wanted a present not predicated on extermination. Wanting to call or dissolve into voices from which everything had been taken. And unable. *That's that,* a man says, coming to the crux of his particular power, which is not naming, but the will or ability to avoid a mess that cannot be cleaned up.

•

1954. The task of announcing that the government will triple funding for interstate highways fell to Nixon. Ike had a funeral to attend and so did not face the crowd that assembled at Lake George for the annual Governors Conference that July. It is not an easy thing to decry New Deal policies as *jitterbug economics*, then put forth plans for what will prove to be the largest public works program in human history. But some comments were prepared and he did what he could. If years are important to you, it has been eleven since over twelve thousand acres directly southwest of Lake George were bought by the United States government and converted into the Pinecastle Bombing Range. It is the first in which the government will record the number of highway fatalities, of which there will be thirty-three thousand eight hundred and ninety. If imagination is important to you, imagine that on this day the range was kept quiet for the conference. The sun shone as expected as Nixon placed his paper on the podium and probably he was sweating and itchy in his wool suit when he asked the gathering of intermittently beaming faces in front of him, *Where is the United States going and by what road?* He answered his own question by explaining that our country's ascendency was being compromised by a system of highways that *is obsolete because in large part it just happened.* Before it will make a habit of pointing out that highways will save lives when atomic bombs are dropped on our cities, Ike's

administration wanted to make it clear that this country's embrace of automobiles made such an expenditure essentially inevitable. That they did not believe in social engineering or systematic planning because they were not fools. There were so many gung-ho local initiatives to fund and so many ways that a paved ribbon could be pulled through your town that of course there should be no expectation of an overbearing policy telling you how to do it. This was not the state getting in anyone's way, but a government supporting what was already happening. A government so attuned and aware of what everyone obviously wanted, and quite willing to help them want it more.

2007. I want to say that they are sense-records. That the nets and skeins we stand before will mark the body where it is mute, grueling, and stupid: *slight tinnitus upon exiting the subway, taut memory of a sunburn*. As if to make a finding, written and rewritten into an open notebook, a synesthetic telepathy. Because in Jack I felt alive to a refined kind of stupidity, one I had a home with: so big and beautiful as it sought always to have it both ways, to be somehow both open and domineering. A rejoinder to your worry that a world is wasted on you, since each bit can be registered, enlaced, held aloft, cradled, appraised; though as you begin to speak a word toward it—even a beautiful word, like *catachresis*—you will only admit that you've utterly missed the point.

•

Dear Jack,

I have collected such little cards for most of a quarter century—I have them with original sketches from Howard Chandler Christy, James Montgomery Flagg, Leyendecker, Aurebach-Levy, Arthur Szyck, Grandma Moses, Gluyas Williams, and many more—and would like to add one from you to my album. From the very moment I saw examples of your work in Life *Magazine I knew at once that you had mastered the ease and graciousness which is the essence of real art. I wonder whether Mother and Dad would resent a dictated letter from me. You can't drop off a somewhat scary seeming package at my door and then claim that you won't be contacting me for a while. In any event, one is struck by the fact that two centuries have produced but few individuals who we can without any hesitation be put into the classification of great. I bought a Pierce Arrow automobile as I can afford it and believe in enjoying my self between wars. My exercise is supposed to include a short swim in a warm pool each day. Not long ago I had to come through the city again, gray in leftover rain. I saw our old apartment house from the bridge. It is a bit dingy looking; otherwise unchanged. The river was overflowing its banks. Have a headache today. Think my eyes are a bit strained. But all in all, I feel OK. He has a habit of vagueness, out of which I hope he will grow. He wanted to get some cash, so I arranged it—rather Colonel Lee did. I constantly get letters from anxious mothers begging for their*

boys to be sent home. I thought we'd agreed on trying to get coffee or dinner or something this evening. You were going to call me today. Another issue of Life *arrived and I read the article on myself with some interest, and more amusement. It is odd how these reporters can go back so many years and dig things up.* My *correct* name *and the* correct *place of my birth. Well, reporters must earn their pay. For some reason I have never been able to sit leisurely at a table and take my time enjoying food. The trouble had come about in a most curious way. It is difficult for me to remember that an expression of the slightest whim or wish on my part is likely to start a lot of things in motion in a hurry. I try to name it and it does not end. It's an inane, frenzied pantomime, though also cherished, at least by me. I think it's great that you're meeting people. I don't want to be young again. All of this is of no interest, but it does give you some understanding of the thoughts that began wandering aimlessly through my mind this morning as I have dictated between appointments. I'd like to get out for a short walk today, and really hope to make it before dark. The only trouble is that the area in which they will let me walk, without a flock of sentries, is very constricted, so there's nothing but a small circle to tramp around.*

A line demarcates. It renders and/or connects. Géricault rode horses and thought it would help him paint their galloping more accurately. Abstraction thrives in the spaces where many are amassed and dependent upon one kind

of mark. A light turns red or gold. A bell goes off. White smoke rises from damp, smoldering straw. A ball finally drops and everything on screen flutters.

Nixon, who your favorite singer-songwriter kept an odd tenderness toward. *Hospitals have made him cry.*

Doubts about getting anywhere as one way to remain at work. *Enlisting the viscera* another. Increase is a line relying on limit. Put otherwise: What would it mean to be so wrong that you could come to feel wrong enough? To be so lost into what you thought you were doing, so concentrated in your incomprehension, so nearly blind to your hand that no single thing that watches you will ever adequately appreciate your fear? Both Pollock and Kerouac chose a medium—the Novel, the Enormous Oil Painting—that had come to hold itself in the highest regard. This helped inform their particular desperations.

Sagebrush was cut from the desert to fill in the wheel ruts and school children were massed with flags and the band furnished music as they were presented with six boxes of Morgan's famous canned peas. The paulin of a truck burst into flames as it pulled into camp. The bridge was made passable by hacking its roof to pieces.

I saw him once, on a spring day during my last semester of school, sitting alone next to the steps of the admissions

office. And thought it strange he looked so much like himself, and so did not think he was who he was, because there was no crowd around him, only this smiling, slightly wizened guy with overgrown wispy hair, staring up at the trees.

Another myth about *Mural* is that it hung briefly in the university's cafeteria. Peggy hears a version of this and asks for it back. She offers a canvas by Braque in exchange. This offer was rebuffed. The official explanation was that the university preferred to have something done by an American.

Rhetoric, Miniature

Jack and Neal go driving through the woods and hills. Jack and Neal hoot and moan and fuck girls in every other town, just like you heard. They see more and feel more than you ever will, but whose fault is that? They drive to the Bay, to Mexico, back to Denver, through the flyover land and back to New York. It is 1947. *Mural* has had its first showing at MoMA during April and May.

Boredom Points

.

Arriving two weeks later and becoming enamored with Coney Island.

Particulate flecks reflecting white, the pace of aluminum stakes.

Elsewhere explained as an outgrowth of her support for our department of art history.

•

An approach as old as rendered herds of rhinoceros in cave paintings.

A flatbed trailer to haul farm equipment to California and two sunburned brothers who said *get in*.

Imagining deities as unreconciled events, animated by grudges, stuffed with lust.

Sandwiches of bread and butter; a dime for mashed potatoes and a stick of ice cream.

The same bird several times upon a test sheet.

A child asleep behind the hedges.

Its use as a teaching tool.

Reading every word a year after running just enough to break two bones in my left leg.

Giving forgettable head and so was flipped over.

The most fantastic parking-lot attendant in the world.

A brief dialogue filmed on the bluffs with a secondary character as a way to include the name of Becky Tarwater.

•

A technique later applied to processions of gas-masked troops and angled bayonets.

Dear Jack—After finishing this letter I shall go down to a nearby newsstand and steal the change on the papers and go buy some bowery beef stew.

The moment of death cannot be known.

Braque, of whom Picasso said, *he was my wife*.

The legs of ibex or reindeer pulled entirely outward from the trunk, as if in flight.

From Delphos to South Bend, South Bend to Rochelle

1931. Orozco and Benton spend the first month of the year finishing murals on separate floors of the New School for Social Research in Manhattan. Jack manages to get an introduction to Orozco because Benton has brought him along for some action-posing on site. While Jack's face is not particularly recognizable among the figures grinding through appointed tasks in the *America Today* series, this was not always the case. A few years later, Benton will watch Jack try to play the Jew's harp while sitting in with his makeshift bluegrass band. They call themselves the

Harmonica Rascals. Jack generally sounds terrible while looking convincingly folksy. Benton will ask him to be the model for a harmonica player in *The Ballad of the Jealous Lover of Lone Green Valley*, where a near-total lack of musical ability will not prevent Jack from adding to the atmosphere of the tableau. The painting depicts a scene from the Ozark murder ballad of the same name, every element arranging itself around a colorless blade in the title character's hand. The song sings of a moon shining *brighter than it ever shone before* and so the painted sky is as light as an early afternoon. Everything is inundated by a steady, languid writhing that somehow remains a kind of torpor, like the half-dead eyes of the yokel across the table from Jack, or the fence slats stuffed with fog. Jack's eyes cannot be seen. His skin is pale and smooth, his expression disappearing into the instrument concealed by his enormous cupped hands.

Dear Jack,

You are still sincere, but automatically, the process of writing forces you into a form and therefore, you just say things rather than feel them, and the honest attempt to express these feelings is too much so you just, lazily, dash off a newsy letter, or pat formal stylized letter, or a wild artificially stimulating one and so on. Those things are for anyone to do, but not us, so to play safe force yourself to think and then write rather than, think what to write about and what to say as you write. Incidentally, I sense just a

hint of the above falseness in your letter, but, I know it's
just that there was really nothing to write about. That's
that, now to answer your letter.

You flatter me unnecessarily about my Kansas City
letter, I was just drunk and high.

I don't know what to say after reading your terrific
telling of your experience in the parking lot.

1919. In November, Ike forwards his report on the Trans-
Continental Motor Truck Trip to the Chief Motor Transport
Corps. He calls Iowa's roads *impossible in wet weather.* Because
the Midwestern terrain crossed by the Lincoln Highway
was consistently wretched, Ike recommends a thorough
investigation into all options for other *possible routes for*
building a road, before any government money should be expended
on such a project. He sends this report from the Rock Island
Arsenal, where the friend I spent part of a summer painting
a building with eventually has his wedding reception. His
bachelor party was the first time I ever went to a strip club.
I remember that it stood among the cluster of buildings just
downhill from a Coralville truckstop, almost all of which
have since been razed, and that I was easily flattered by one
of the dancers. She came off the stage and sat on my lap
with a spangled knit shawl across her shoulders and when I
told her I had no money to pay for a lap-dance she said she
only wanted to play with my hair, and continued to do so,
and this thrilled me. Still living in Boston, where A. had
left me a few months beforehand, I had been sleeping on

the couches of friends for a few weeks. The Rock Island Arsenal is one of the oldest white settlements in the Quad Cities, a name also encompassing Moline, Bettendorf, and Davenport, split between Iowa and Illinois by the Mississippi River. My father's parents moved to Bettendorf before his senior year of high school and they lived there every year that I knew them. There were adjoining yards behind their house and a grade-school playground within walking distance. We exited the interstate within view of a strange hotel that looked like the stage-set version of an Alpine castle or something. When I asked the woman on my lap about her retainer she covered her mouth with both hands, then actually threw her head back to laugh and said she'd been working there for months without a customer noticing. It almost occurred to me that my parents had no real problem paying for braces when I was thirteen or replacing the retainers that I absent-mindedly threw away with the remains of a lunch I brought from home in a paper sack. I hid each new mold and wire fitted to my mouth, removed, then concealed well enough in quotidian brown while I ate there beside it, trying to avoid the disgust of anybody sitting near me. I tried to keep my eyes near her face and began to explain that I was really a very wholesome and observant person and she kept her mouth covered and continued to laugh.

Though when it comes time to reenact the whole thing ninety years later, the convoy will have no ostensible pur-

pose aside from military recruitment. Sergeant Eugene W. Latsch Jr. helped to restore a 1918 Dodge for the journey and told a reporter he expected it to start a few conversations. *When we start going through these small towns these kids who don't see this kind of thing will be amazed. It's something new but something old.*

According to one account the young men would trample the beast. And when it was too large to be killed in this way it was slaughtered in the conventional manner, though *a simulated stampede is still performed as a prelude*, as the ground of unanimity.

The argument goes: define your terms or assume their transparency. It may be that abstraction itself came to feel like an excess or indulgence. Simultaneously, we have read, there was a renewed suspicion of being ruled by it. A country grows accustomed to calling so many places *soulless*. Or feels reasonable, affirmed and reassured by the claim that we cannot know a crowd without knowing it as already split apart, organized, set against itself, arraigned, or sent home.

Darling J.,
This week we got another lecture from the little king of everything. He went up there and started reading off injunctions—thou wilt follow me, through trials thou wilt follow me, wilt follow me best, of the others thou art the one

who will follow me everywhere, like a little dog thou wilt follow and on and on like a motor, like a numb little spring and I loved it. He glanced at what I'd done and said there was already too much there and I agreed and so started taking vows of silence for entire evenings or days and you might consider it a shameless ploy to say so but mostly nobody noticed and so it solved nothing, like writing—but the spread of it, the way it holds the glint of shattered glass like jewelry beside the highway—why do I need a name for that? Why do I need to get that down? I was thinking about driving back from the city with you, the morning after that gallery opening we got an invite for because you'd been an extra in one of the photographs. Driving or being driven, I can't remember, but the show was crammed with impressive-looking people and the photographs were enormous and lush. You stood in front of them and felt pleasantly captivated because they were immediately mysterious and unequivocally beautiful and then they were kind of boring and it felt easy to walk to the next one. I watched a camera-flash smear across the one with two wolves on either side of a man face-down in the leaves and grass beside an open car door and then I saw that director we later agreed was overrated and the lenses of his glasses were as big as hamburgers or fists and someone said he was pretty sure that the woman to the left of the one with that swarm of butterflies hovering in thin lit vapor was Cindy Sherman, though I will admit that this did not have the same charge for me as recognizing the guy from the B-52s who exclaims

you're WHAT? three quarters of the way through "Love Shack" stepping from the sidewalk into a cab. I remember it seemed glamorous just to drink at the bar down the street from the gallery in the form-fitting black shirt you bought me for the occasion. That you were calm, almost affectless in the middle distance of the shot, standing to the left of the flowers heaped nearly to the height of a telephone pole. Your feet bare on the lawn behind a chain-link fence, your red tank top. Quizzical, maybe. And somehow so matter-of-fact. I was remembering that, generally. And a gauzy yellow light caught in the window of the houses standing on either side of the street, and that generally Connecticut was where we fell into silence. Alone together in a corridor of pines, and how the thought that always recurred to me was that someday one of us would die before the other and the idea of being allowed another moment together, to touch or to speak into, would be bewildering. The thought was a circling whip with nothing in it. It made me frantic. Beside this thought there was another: you sound like a ten-year-old. *If I had ever spoken any of it to you, I think you would have agreed. I tell myself now that these things are commonplace enough to include only as a way of saying that I am largely uninteresting, or pretending to be uninterested in my own story—or that any number of things, must be so private that they are common.*

In his autobiography, Orozco will write that Mexican mural painting *began under good auspices* and that for this

reason even its errors will remain useful. His own might include several of the preceding pages, which maintain a strict and predictable division of artistic labor, chastening the naïveté of the open-air school that preceded muralism as being not simply crude, but an affront to the obvious fact that Painting is for Painters. Expecting to see something in the work of people who clearly don't know what they're doing is the same, he says, as asking that Beethoven be performed by a suckling infant. Or by taco vendors or bus drivers, or someone selling lottery tickets on the street. He goes on to explain that the condescending interest of the art-world cognoscenti in fourth-rate work by untrained hands could only be fully illustrated by dipping the tail of a mule into oil paint and allowing it to swing haphazardly across several canvases. These should then be displayed anonymously in a Paris salon, where critics will write about their audacity of technique and their *brilliant, unmitigated colors*, bringing philosophical and theological considerations to bear upon their praise before announcing that these paintings truly mark *the dawn of a new revolution in art*.

The log records *thunderstorms* and *broiling early summer heat*. With heat, the persistence of vapor lock. The engine coughs, turns over. With thickening storms, a memory of *the mud in Diyala Province, Iraq, in January*. Some *pretty incredible slick, sticky mud*, the log says. Breakfast in Gretna was *Spam and fixings*. Afterward each participant was given

a brick from the original Lincoln Highway. The log says *throat-clogging dust*. Sore neck. Cracked hands. Says it sent a letter home. In Catigny, a Patton impersonator stood on the running board of a jeep, directing traffic.

2007. It takes a few minutes before the first visitor is reprimanded. She was blond, in denim and beads, and she looked startled when the guard said sharp and firm, *Ma'am, step away from the painting*, which was *One: Number 31, 1950*. She seemed embarrassed, but also defensive, repeating in French-accented English that she had not touched it, incredulous that anyone would think she really didn't know any better. But watching her, I suppose we could not, since what she did was almost the same as each of the four people I saw being admonished during the next hour or so, in the same room. Two were prepubescent children, though it was the second adult who chose, while slowly sweeping a hand just above the canvas, to make a series of sounds. A percussive hiss with the beginning of each enacted line that could be followed first with the arm, then the feet shuffling a little to the right before being told *You are too close*. You are too close. Don't say that you are sorry, just be reasonable. I tried. I asked the guard how often this kind of thing happens and he said just about every damn day.

With Ike still in the service, legislators are maintaining that even if the highway itself will not exactly make parks, heliports, marinas, modern apartment blocks, or

exposition halls, it will inspire them. It will both protect downtown business districts and enhance what the panel delicately terms *decadent areas*, which the highway will set about restoring to *a tax-paying condition*. Its only real obstacle is this insistent pilfering of what we owe to it. Specifically, that in 1936 nearly one fifth of the funds set aside for road-building was redirected into city remodeling, public education, and work-relief funds. The panel of nine engineers presenting this information to a convention of road contractors will declare that such budget diversions amount to nothing less than an active policy of *discrimination against the American motorist*. Legislation to prevent such discrimination will pass shortly thereafter.

I can find no printed reaction to the policy shift that celebrates the newly obvious analogy between the highway and its reservoirs of funding; observing that each is now more freely able to imitate the other and thus to become an instrument devoted solely to motion and open to its imperatives; that each can now seek more and more to be a looped thing, a sealed thing, a thing streamlined and feeding on its ability to grow larger and smoother and more congruent with what is simply the given, the indispensable, the obviousness of common sense.

Patton, who spent days laid up in Davenport during the summer of 1919 with chickenpox, writing poetry.

•

1943. Further forgotten within the thought or semblance of him sitting and producing nothing for months but more cigarette butts and bile, staring into the obstacle of Jack's Enormous Unpainted Canvas: that equivocation splits. That these were, in fact, the weeks and months in which he would paint some, possibly all, of the four small canvases from that year that would also make claims upon his future. Though it is not just their scale, but their indecision about line—is it the rind of shape and contour or a kind of irretrievable exposure? Will we hover or touch?—that makes them, if not exactly timid, then provisional. And in almost no way spectacular. They don't contain or unlatch any of the pressure or expansiveness Jack later required or sought, to show something flourishing or drowning in flames and murk, in sanguine acts of knowing when to stop or not; in tantrums or the limits of what will fall away or adhere. This promise of appearing. Of being other than the world. This is one way to align the tantrum, its encompassing flush, its unsurpassing concentration. Though Jack's individuation and/or catastrophe, at least within these paintings, is also provisional. In part because *Composition with Pouring I* and *II*, *Composition with Vertical Trapezoid* and *Water Birds* are also his earliest sustained explorations of a method that was not his own. And while you can select among precedents— Max Ernst swinging a punctured paint can on a string, Hans Hoffman completing *Spring* on a panel of wood a decade after leaving Munich, one among the estimated hundreds of

examples from Asia or the Atelier 17; or you could specify a term like *compound pendulum* or a date, like *1940*, or you could choose, as Jack did, to cite the Navajo practice of sand-painting—this does not change the fact that an act came to be synonymous with only one name and that it was his. Even as there came to be no agreed-upon word for what he did or was doing—*pouring* or *dripping, throwing* or *spattering, dribbled* or *splashed*. Even as he came to hate these verbs and his more sensitive commentators came to find them more and more misleading, so that eventually this work came to be more and more often described as essentially indescribable. And it lingered there, in that aporia, as a singularity or the promise of it, or what that promise was staked upon. Thus it stewed and soaked, tapering in its blooms, in its transparent inscrutability. And repeated what was old, but new and what was still oncoming.

He began by writing in pencil about a dead cartoonist named Jack Baloon, whose final wish is for his melancholic brother to hand-deliver a series of letters to friends in New York, Denver, and Mexico City. He began by describing a woman's brief marriage to a lazy card player named Smiley. He began in the hypothetical: *If you spoke French, like I only spoke till I was six.*

2009. Not that they really thought or believed that trundling across the country inside a string of antiques would grab the interest of an incoming generation of warriors. You would need the shine of something

hulking and contemporary, for comparison's sake. At the Letterkenny Army Depot onlookers will be given *a real opportunity to see the changes that have taken place since 1919. The depot provided three humvee variants that have become the work horse of today's Army. An Avenger humvee gave a glimpse into front line air defense with it's Stinger Mounted turret, a SOCOM Ground Mobility Vehicle displayed the modified version currently deployed in Iraq and Afghanistan.* . . . *In addition, the depot displayed a new Mine Resistant Ambush Protected armored vehicle* developed in response to the insufficient protection humvees provided against improvised explosive devices. Coalition fatalities in both Iraq and Afghanistan, as of this writing, stand at over eight thousand. It is one thing to polish up some old trucks that will bring out the hobbyists and the armchair historian set, another to excite a child. It may be that a seventeen-year-old could give a shit about your tinkering with an Airstream trailer, but feels somewhat differently about the proximity of something nearly indestructible. Explain that it is the V-shaped hull built into the underside that will deflect explosions beneath the vehicle, that it depends on the configuration but the MRAP can weigh up around seventy-five thousand pounds and sure, you can touch it. Though if you wanted to continue making comparisons and so sought more figures, like the number of Iraqi and Afghan civilian deaths since 2001, there would not have been nor will there be any official government tally to point to, because none is being kept. *We don't do body counts*, as the general said.

•

While nothing could be more obvious than the fact that, for us, or at least for me, before these are paintings or sense-records, or an art announcing that Everything Is Possible, Nothing Is Forbidden, they are one among many options for digitized wallpaper. They are dress patterns, or a backdrop exquisitely photographed by Cecil Beaton; they are shorthand for *lively* and *wild* on interior design shows. Before these are paintings, they are reproduced and printed onto a layer of cardboard, then sliced into glyphs and placed into a box labeled *The World's Hardest Jigsaw Puzzle*.

One version of the Federal Art Project's beginnings has a former Groton classmate of Roosevelt's by the name of Frank Biddle sitting down to write a letter in 1933, encouraging the president to consider working an art component into the WPA. He cited Mexican muralists as an example of artists willing to work for *plumber's wages*. Roosevelt, who is mostly interested in paintings that have boats in them, becomes enthused at the idea and passes Biddle's letter on to the Treasury Department. This is the year that a crowd in Le Mars, Iowa, will drag a judge from a courtroom after he refuses to halt foreclosure proceedings. The paper of record describes the crowd as *one hundred men or more*. *The Militant* says six hundred. In Denison, which lies slightly southeast from Le Mars, eight hundred pairs of hands prevent the foreclosure sale of a farm belonging to

one J. F. Shields a few days later. The governor institutes martial law.

This was how we came to see the highway: at any instant small parts of it are almost always on fire. Outside the instant it cannot be seen. Small parts of it are bought and maintained by prisons and choirs and Kiwanis clubs. Certain circuits and metonymies. Returning to the town you grew up in is not the same as saying you plan to die there.

If I tell you that there were fifty thousand, three hundred and thirty-one highway fatalities in the United States during the year of my birth, then offer to count down from that number to the first one you consider more comprehensible, can this be anything but unrealized farce? Is it more accurate to say that we live *within, beside,* or *upon* a banal type of sublimity that is not aesthetic but analytic? This is not solely an argument about history. Kant says that the analytic sublime pairs an incomprehensibility of scale with the barest sense of number. His example is an Egyptian pyramid that the eye will draw close enough to count a few bricks of, before looking up. And since I couldn't, I wanted to ask him if this precipice is in any way negotiable or plastic. If, perhaps, regular exposure to particular places shifts the point at which an experience of number becomes unthinkable. Regular access to a stadium, for example. He never saw a pyramid in person, but

neither have I. Possibly this misses the point. Possibly it is a fool's errand to begin again by asking what begins or ends in being late to the moment of precision receding. To be given or received by abstraction, fat with answers. And what it taught, this unfeeling in number. Rephrased, this read as *the idea of a precipice where something legible and delineated turns definitively into Dance This Mess Around i.e. only a claim or fable of thinking or a thing still trying to do so, trying to name its terms in precipices and points, as if to unstir cream from a cup of coffee.*

Feverish and bedridden, he sets his scene in negation, not amidst chanting nor *neath misty shadows from the oriel glass* but in an older kind of quiet Patton calls *the subtle stillness after the fight, / In the half light between night and day.* The body is recovered, then dragged *besmeared with mud, / and dropped . . . clod-like, back into the clay.*

Robertson, who wrote that *when pushed to the wall, art is too slow.*

Joan piled loose sheets of typed paper beneath her bed for the last ten years of her life. Her daughter collected them in 1990 and began looking for an editor. Janet, the child Jack would not directly acknowledge, will also write an introduction to the version of her mother's memoir that is assembled for publication in 1995. In it, she remembers her in an old turquoise sweatshirt, typing with two fingers. She

says Joan was a perfectionist and probably would never have finished the book if she had lived. That she rewrote the first sentence over and over, unable to make herself satisfied with it. The published version of this sentence begins with the phrase *I opened my eyes in darkness*. No variations are included.

Slotted Mailbox, Telephone Pole

A year before he begins to work for the mural division, Jackson moves into an apartment above a lumberyard and is hired on as a part-time janitor for the City and Country School on West Thirteenth Street. He shares both the apartment and the job with his brother Sande. They get the job because the Bentons know the school's founder. Charles, the eldest of the Pollock brothers, teaches there. Occasionally Jack and Sande steal food from pushcarts in the hallways.

Jack gets work as a stonecutter for the city, which actually means cleaning bird shit from a statue of Peter Cooper

in the city square that shares his name. He brings a little stepladder and climbs it, leaning across the statue's lap, steadying himself against the marble pedestal to soap Cooper's lapels and cane, his knees, his forehead and shoes. Cooper, who designed the country's first steam locomotive and got a patent for the manufacture of gelatin. Jack pulls a toothbrush from the pocket of his wool coat and soaps it, then rubs its bristles across the bronze whiskers and eyes.

An early observation of what came to be termed the time-gap experience occurs not in an automobile but a radio booth, near the end of a disc jockey's day-and-night set. They track it by monitoring the movements and blinks of the eye, aligning electrode scans with deductions about the modes and flow of repetition within near-uniform circumstances. The subject simply reports no memory whatsoever of the moments immediately preceding the question, though both eyes remained wide open the whole time. I imagine they were pleased to create a designation for something so familiar, though they could not prevent these lapses easing open and snapping; attached again and again to a sense of arriving back, emerging again to your hands and breath. If not a gap exactly, then a sustenance we cannot name. Shirking. Tepid. Recalcitrant, dazed. It returns to insist it is not material or not entirely, and yet not entirely free, though it cannot name the thing it was wandering in. Because we are so quintessentially there and not as we glide in the eye of the highway, we are banal. We become a braid

or station. Not a thought or a thing, but the fault between your journey and your surroundings. Thus, the highway is memory unstrung, the harbor lights appearing and immediately inconsequential. Teaching us how to be anxious and drifting at once, showing us a marbling of countercurrents. We go there to forge a thinking that is quick and lackadaisical, as impossible to touch as it is to set aside.

Expressionless, Adorno called our roads. They seem somehow to have always been there, *as if no-one had ever passed their hand over the landscape's hair.*

To feel constantly overcome by both restlessness and an unyielding need to be lazy. To be drawn into dim jittery torpor. Awash with an anticipation continuously exhausting itself. Name this affliction *adolescence.*

Say Jack began as a fire lookout atop a mountain in the middle of the night growing very very bored and stymied and tiring with time but unsleeping; then wanting to write a way out of it with the avant-boilerplate gestures of an age so available to him, thumbing past *blood* and *blade* in the dictionary and the pop of the keys as he hits them *Black black black black bling bling bling bling black black black black bling bling bling bling black black black black bling bling bling*

That one might learn to hover, like a kestrel, somehow attached and unattached.

•

Dear JK,

And when she said I'm not going to replace her *I said ok. And when I poured the entire sugar packet into my spoon before dumping it into my coffee she said* that's kind of interesting *and I said* really? *Or it was two-thirty and she looked at me and asked* are you sure that's all you want? *and I was scared and said yes and she went upstairs and I slept on the couch and it was that night or another that I had that ridiculous dream of being wrapped around you on an aluminum saucer skidding across the ground in winter and the pulse of little bumps and hummocks, our gliding between them then lifting and lifting and in the morning we listened to election results being repeated over the air and we did not scream or weep though we were not numb or not entirely and I wanted to say I was mostly afraid of losing you as a friend but I lost that anyway. Or it was nearly three and not you but your friend who closed her door without me even asking so that we could disappoint each other for a while while you laid awake beneath a blanket on the couch and was it a week later or two that you said maybe stay and if the color of the couch is included as sea-foam or its angle or the taste of your teeth and I am no damn good at this and you said maybe, maybe not, now get on your back and I said ok. And when my head was pulled between your knees they trembled; and it is that or the ease of saying so or claiming it, or your namelessness here beside a petulance repeating each* I'm

125

not the same as the recurring panic of a pop song played for dear sir, we form little occasions for your history so conveniently, like four parts in an alphabet or your name is please just shut up and put your hand there ok. I wanted to say that I was trying to untwine act and feeling or simply to separate love from fucking, like any competent nineteen-year-old, but I was twenty-five. Your favorite director called this the year that youth ends, but that was before the Real Housewives *franchise and all of that. I meant to say that I wanted to bind my desire to time and deferral and you happened to be there and so I returned again and again to gawk and ask after what you disclosed or refused. And so felt almost catered to, as you offered yourself and gave no sense of comprehension, or of our discovering anything at all. The travesty of pressing these things upon you felt almost sufficient, almost unmanufactured, so cozy and used. Put otherwise: I found my way to you when dissolute and rote in my fumbling, wanting so much to come into grace or something unlearned. On my chest this time, she said, this time I want it all over me.*

Then half an afternoon in the psychology library, trying and failing to find a written distinction between time-gap experiences and hypnagogic states, more broadly defined.

By 1955 commercial firms developed a functional model of the slip-form paver wide enough to lay two full lanes. Twenty-eight miles first appeared just outside Des Moines

a few years after my grandparents moved there, three after my father was born. The Quad Cities Construction Company laid each mile with a newly modified version of the machine, which advanced not on wheels, but crawler tracks.

A mystic of the object, Kristeva called the adolescent.

Dear Jack,

I had a bizarre dream which, I think, had its starting point in fond memories of cuddling in Hyde Park. In the dream, I was cuddling with you, but another you was walking around, looking a bit dejected. In the dream, you were my friend (the you that was walking around) and I felt kind of bad, but it was my boyfriend I was cuddling (and, in fact, it was you), and I figured you'd take care of yourself. Then it cut to a scene where I was talking to my sister and I said that the thing was, you didn't understand that I liked both of you since you had been the same person (as though these versions of you were the same, but just at different times). Weird!! Very sillily metaphysical.

Uh, yeah. Study THAT. And now I'm going to go write up a brochure that claims something can be learned from analyzing doodles. (The problem with my presentation is that it's ridiculously wispy subject matter, but I have to pretend I take it seriously. An internet site said that if you doodle about transportation, you'd like to move around. Ha.)

*Also, I've decided what additional "Christmas" gift
you can get me: either filch from your father's or your shelf,
or purchase, a book of short stories or something for read-
ing in the car.*

When he was alone with Benton's son, Jack liked to tell
him stories with a recurring character on horseback who
rides through the rattling gold-rush towns at dusk or walks
into the mouth of an abandoned diamond mine with only
a lantern, arriving at every empty campfire in the middle
of the night to find it still smoldering, then beginning to
hiss beneath a few drops of unexpected rain. He names
this figure Jack Sass, a character who indirectly annoys
Benton to no end because, when the sitter has gone home,
the boy begins retelling every story, and frankly they are
tedious and silly. Still, it was difficult to get mad at Jack,
as shy and bumbling as he was, soft-spoken and polite at
the dinners to which he invariably contributed a single
turnip. The first time he was served spaghetti he had no
idea how to eat it and had to be shown by Benton's wife,
Rita, which everyone found amusing, though it's not as if
twirling spaghetti into a tight spiral on a fork is anything
that simple or natural. I remember slurping it in extended
strands when my maternal grandmother visited us from
Pittsburgh and that when she told my mother that the way
my cousin and I were eating was making her sick it turned
into a shouting match and she left with my grandfather
and got a hotel room, then drove back to Pittsburgh the

next day. That later I found out she'd sent back our school photos torn to pieces. One definition of melodrama is an excess of plausible emotion, though this is not exactly the way that the Bentons found it difficult to believe that the same young man who sat nearly silent at their table had dropped to all fours on a sidewalk in the city late one night to play with the dog that a well-dressed man was taking for a walk before he straightened up to his full height to ask the owner how he could take care of some damn dog when Jack was standing here in front of him and practically starving. It isn't clear whether or not Jack lunged at him first, but either way the story continues with the well-dressed man simply kicking Jack's ass, actually putting him in the hospital for a few days. Rita comes to visit him. On the day he's sent home Jack will be informed that the assault charges against him have been officially dropped.

A Fool, Verily a Face of Wood: This is said of a shameless one, of a brazen one—one who in truth rushes into the presence of the illustrious.

1969, a year in which services are held for both Kerouac and Ike. The latter includes a twelve-car funeral train that arrives in Abilene, Kansas, five days after Ike's death. Police estimate the crowd at the burial to have been between seventy-five and one hundred thousand. Others meant to come, but were caught in a three-mile traffic jam on the new stretch of highway.

•

1969, a year in which fifty-five thousand and thirty-two lives that were not ours will expire upon the domestic highways of the land where vitalism went to wear itself through. These, our fellow creatures.

Ronyon: bare in places, wretched, scabbed. Began *we spent all morning on the highway and were all morning among guests*. Rita or Bea or the name that was told him; the most beautiful bevies or the most anonymous and misgiven. The one that is and that which is thwarted; the way a space is made unlivable and undead and what is touching there. *A black whorl interlaced with yellow, some musty pink, that sequence of short blue verticals in it, tipped, like matchsticks*. A fantastic caricature, adjacent on paper. *Unaware of how we truly appear to him*. The sum of possibilities and the one that is more than a possibility; the all and the except. *Paddock*: an enclosure, for exercise.

2001. In this year the number is thirty-eight thousand, four hundred and ninety-one.

He thought about calling it *Though I Go Ten Thousand Miles*. He wrote out the title, *A Road as Long as the Night*.

2001. And in the so-called *third world*, just over a million.

During the year that Jack is commissioned to paint Peggy's hallway, a WPA storage closet is cleaned out and a dozen

of his watercolors are among six hundred and fifty incinerated. They are not degenerate, but clutter. I can find no record of Jack's reaction to this outcome. Or to the story, if it was ever relayed to him, of the thousands of paintings produced under the Federal Art Project that were pulled from their stretchers and auctioned off at a Flushing warehouse, alongside scrap metals. Each was priced by the pound. Included are works from Milton Avery, Alice Neel, Rothko, and two from Jack. Individual canvases were priced at three dollars apiece in a curiosity shop on Canal Street. Several of these are purchased by the proprietor of a frame shop after they failed to serve as insulation, the function a plumber had planned for them after he bought the lot at the warehouse and hauled a few into his basement, where one was wrapped tightly around a pipe. The heat began to burn away the oil attached to the canvases and the air filled with a sharp, acrid smell. Will your exemplary illustration of art's relation to materiality be found here, or in the oft-cited support Jack will later receive from the Congress for Cultural Freedom? Established by the CIA in 1950 to covertly fund cultural and artistic work it viewed as instrumental to winning the Cold War, the CCF arrived just in time to find that Jack was not a liability but an asset. He went on to receive undisclosed amounts of support from them for years, and was not alive to offer any comment when the program's existence came to light in 1967, eliciting first incredulity, then proclamations of betrayal. Abstract expressionism was the CCF's butter

bear. A vibrant, indispensable example of individual flourishing, liberty underwritten by an unfettered market. In this, Jack became available for export. Which assignment would you prefer: trying to imagine a moment when an artistic movement being co-opted by power provoked genuine surprise and indignation, or explaining how it could be that the cringe provoked by the story of a painting's disposal outdistances anything we would likely have felt when viewing one of the canvases that smoldered and stank and got stuffed into a dumpster that afternoon?

And it may be that the present state of a continent's geological knowledge of itself is in fact inseparable from the road cuts that came across it in the middle of a century, that a set of insights opened and remained among the unplanned consequences of the highway; these pitted surfaces just beside it, one among several of its effects.

Jacob Eisenhower, Ike's grandfather, was a noted preacher and patriarch within the River Brethren church, first in Pennsylvania, then in Kansas. They built a creamery in Abilene where Ike's father went to work as a refrigeration mechanic for less than fifty dollars per month. The family left the church when Ike was five but carried its imprint: no swearing, no booze, plain dress, pacifist. His mother made it known that his going to West Point aggrieved her. She played the piano and sang hymns before prayer meetings. The only president baptized in office: Presbyterian, in 1953.

•

Not a word of Joual was spoken at Kerouac's funeral.

The highway replaces space with motion. Its domination is so fleet and accommodating. Time-gaps affirm and agglomerate what is active and passive within us. A seething that is scentless; its faceless shape, its thrall.

Like my grandmother in Pittsburgh after the war, Mardou or Alene found work as a typist. Mostly she worked for Burroughs, who is photographed beside her in 1953. The picture was taken by Ginsberg, whom she also typed for. Burroughs is wearing a beautiful houndstooth jacket and horn-rimmed glasses. The city is behind them in horizontal wires, brick, and clotheslines. Distant sheets and undershirts hang to her right, one sequence level with her eyebrow, another with her cheek, a shore of bright white above and below the line of her gaze toward him. She wears a small pinched smile, no teeth. A cloth wrap on her hair, thin wrists in a sweater. Mardou or Alene or my grandmother or yours wrote one or many stories. Things were taken from her life. The bottles and cans and the little black bag she found one morning after the friends and well-wishers cleared out. The smell of burnt paper for bedbugs. A sense of dread in the summertime, walking slowly up a winding hill on Staten Island. The memory of eating peaches. She had a sister then, she wrote. She follows her around. When

she breaks a window the sound it makes is *a splatter of glass*. She had a father who was elsewhere. The house where they lived was *rain washed brown, with withered worn splitting wood and rusting nails*, but the view from the hallway was beautiful. *You could see the island as round*.

Began *Give me the glass facings on the marquee over which the movable letters are slid.*

Sifting through a vein of Green River shale two years before these funerals, categorizing hydrocarbons by type: those formed from the residue of what was once living and those formed from events or forces that precede this category.

Spontaneity is a perpetual crisis, a perpetual test. Make yourself. Show yourself. It is your privilege, your obligation.

If we agree to call painting the spreading of pigment on flat surfaces—for the pleasure of the court or otherwise—paint itself begins in viscosity, need, and half-rotten water. It is part milk, part vegetable juice, part pig's blood. It is pulverized ore siphoned into a warm bag of wax and plant resin or a vapor scraped from clay tablets. Open a bag and rub in some lye. Place a pot of vinegar and fermenting horseshit in a corner and scour it for each emerging flake of lead carbonate. Calves' hooves, old linen, a texture of knead-

ing into transmission or a belief that a world, once forged, could be forged again, could speak in rearrangements.

1954. Ike likes to make a decisive check mark or two next to each item covered in a cabinet meeting. Sometimes he adds to the width of an upturned foot to make it a dark rectangle; sometimes his marks become sketches of toboggans, bicycles, or a stumpy tree in full leaf. On the agenda for the twenty-eighth day of June, Ike writes the word *Guatemala* twice in fluid cursive script. He places the word in round brackets, underlines it twice and shades the ground between his lines so that it appears to float like the gunboats he has sketched above the bottom margin of the page. Though it was not marine power but air raids by U.S. pilots that destroyed the Guatemalan government's key military installations, and not actual columns of rebel troops but the reports of their rapid approach that cleared out most of the capital during the previous day. Residents fleeing along the highways saw no trace of them. Initially Ike had balked at the idea of doing much of anything that would further the business interests of the United Fruit Company because those assholes weren't even paying taxes. Eventually he was persuaded that ousting Jacobo Árbenz, Guatemala's elected president, would constitute a vital step within the venerable and ongoing foreign policy strategy termed *containment*. Further steps were taken in oncoming years. Some we have been permitted to read about. It helps and does not help that the

more than one hundred and eighty thousand pages of partially redacted material later released will make the choice to replace Árbenz one of the more well-documented CIA-facilitated coups on record.

In Detroit Jack and Neal sleep in the balcony of an all-night movie house. A double feature spins through the reels; singing cowboys and spies, Peter Lorre and Sydney Greenstreet and occasional sweeping strings, the lingering jitter of three-digit speeds entwined with his fitful dreaming. A seat was thirty-five cents. In the morning they will walk into the street, looking for coffee and eggs.

136 1957. A cloudless day in Wisconsin. Miss Concrete is staring shyly down, lovely in a sleeveless white dress. Miss Black Top is bold, turning her head in calling or cheering, a plume of dark satin fanning from her hips. The rest are men. Grinning, grimacing, bespectacled, pleased with the weather. One checks his wristwatch, another holds an oversized sign for I-94. At the front of the group another holds an enormous pair of scissors, at least eight feet long, looking like cardboard. The blades overlap, pushing slightly beyond one another. Mowing lines striate the sod hillside. Except for these two-dozen people the highway is utterly empty. The line of it recedes behind them into a gray scrim of trees and the off-white sky of the photograph. The overpass is smeared with flags. Forty, in crossed pairs. The ribbon is cut, curling in the bottom right corner.

•

We would like to imagine the story of modern art as a series of overturnings or innovative radical gestures. But every story has its limits. We are not sure, for example, what to do with the choice made by students in Caracas half a century ago, when they obtained five paintings at gunpoint from a traveling French exhibition and held them in exchange for the release of political prisoners. This failed, which is not the only reason to view it as an artistic gesture. Guy Debord points to the historical link between the Venezuelans' tactic and Bakunin's unsuccessful proposal to steal paintings from museums in Dresden during the insurrection of 1849. He suggested placing them across an insurgent barricade at the city's entrance, to find out if this would deter the fire of oncoming troops. Profanation is a kind of question. *Art* may or may not be a word we need to endorse a pleasure that makes us feel complicated. It may or may not be a word for beautiful loot. *Mystical cretins*, Debord called the Beats. A delicious phrase.

Typed onto Army Stationary, 1943

BEGINNING MONDAY AT RADIO CITY
MUSIC HALL-------

"AMERICA"

with EDMUND O'BRIEN
GARY COOPER
BRENDA MARSHALL
Wayne Morriss
Burgess Meredith
John Garfield
Veronica Lake
Ida Lupino
Brenda Joyce
Tyrone Power
Laird Cregar

and scores of other imposing stars!!!!!!!!

The great saga of a young Harvard
man who discovers the real America

from the pen of the great new writer
JACK KEROUAC

Directed by John Ford
Produced by Darryl F. Zanuck
An MGM production ------- Production cost over
$2,000,000

Tradition, Decorum, and That Mysterious Thing Called Taste

If the WPA furthered any art star it was probably Benton, who often took credit for both the dominant aesthetic and the sheer proliferation of funded murals. Eventually their number would come to two thousand five hundred and sixty-six. In 1935 he abandoned the only commission he ever took from the organization, for the exterior wall of a post office. He found the requisite subjects restrictive and dull. Years earlier he described painting a mural as *a kind of emotional spree. The very thought of the large spaces puts me in an exalted state of mind, strings up*

my energies. . . . A certain kind of thoughtless freedom comes over me. I don't give a damn about anything.

1938. After repeatedly missing hours and failing to meet deadlines for months at the Project, Jack disappears for four days to go drinking in the Bowery until he's taken to Bellevue. Eventually, with a reference from Helen Marot, who had helped him get the janitorial job, Jack is taken on as something of a charity case at the Bloomingdale Asylum in White Plains. Here, he sees x-rayed images of his body for the first time. He takes very long baths when he cannot sleep or they sit him in a steam-cabinet, alone. He is subject to regulated doses of ultraviolet light, which, if they went on long enough, would destroy the skin he lives in. They irrigate his colon once and go through the incoming mail every day as it arrives. After a while he is allowed some occupational therapy. As the preferred institution of older New York money, the asylum is outfitted with some impressive amenities: a golf course, two fully equipped gymnasiums, half a dozen tennis courts, a barrel-vaulted assembly hall for parlor games and dances. There is bowling and shuffleboard and the option of strolling around the spacious well-kept grounds that Jack will eventually help to maintain as part of the hospital's garden detail. The assistant medical director has theories about Jack's overidentification with a largely absent father and his all-but-inevitable consequent fixation on his domineering mother, which is consistent with a great deal of the research he's undertaken

on alcoholic men. Jack is, among other things, a textbook. He impresses the assistant medical director with his ready cooperation around the asylum and with the copper bowls he hammers out during some limited time in the metal-working studio. His petition for early release is accepted. A train takes him back to the city. For a while afterward Jack will describe his time in White Plains as basically *a waste* and then he will refuse to speak of it.

Not Prometheus, but his twin who would assign qualities to the animals; each to each, adhering; and what remains. The human as oversight; not sin, but a lapse in distribution. Epimetheus, the dim, a god of distraction and afterthought, of forgetting and withdrawal.

1947. During his time between being a war hero and becoming the Leader of the Free World, Ike serves briefly as the president of Columbia University, a job he finds generally frustrating. In his off-hours he takes up oil painting. He had watched Thomas Stephens painting Mamie's portrait and this provoked or encouraged him, perhaps. Also, Churchill recommended it. For relaxation. And, for now, he has a half-hour in the evenings to do what he wants with, generally alone, generally in the penthouse retreat of their Morningside Drive residence. Often just before going to bed. He will throw out most of what he makes. Later he will say that *my hands are better suited to an axe handle than a tiny brush.*

•

The highway as it runs across the steepest hillsides of Hebei, as it settles through the flatlands and is made a floor for threshing, a crackling thing. Sorghum and millet and wheat, arranged and retrieved with rakes or brooms or open hands that pull the seed from bract and chaff and wait for more tires to arrive upon the highway which is not a field and not a factory exactly but the axis they turn upon. Is this the *real work* we're told we once believed in? And would you call this *story* and would you call this *scene*? Will you say *hurried deliberation* or *husk* or *winnow* and would you say their hands are *reading*?

142 *Comes east, interested in intellectual pursuits; drives furniture to Sal's brother's new house; has cuts from a physical fight with Marylou; just wants some food; wins a footrace; tells stories beside a swamp: picks up a man with a crippled hand; is shown to bear metaphysical value in defiance of the universe; remarks that Mexico is like heaven; sees a white horse and dogs while sleeping; exchanges a watch for rock crystal; is beautiful to look at, but a bit too respectfully crafted; is warm but strangely staid; not a wreck, but not a car.*

If you cannot see it you cannot say it and if you cannot say it then you do not know it and what you do not know you cannot place. To say we see them, see the scenes they clopped along beside or within, in passing, hand-to-hand, not reaching but the distance in reaching. Encasing each

contour; the fine-fingered dawn beside the figure, lovely. The enlivening sight of her rendered by another, cheekbone, neck, and shoulder blade. Pigment pulled across in smears. Explain all need into one small, lithe thing that hides in plain sight. Continually conflate motion and living. Gesture is this inherited, equivocal *both* I make in silence. *I'm a kind of vague, skinny whale,* he began. Contortion or a method of loci, excited by place names, alone in your room. So? So say what is provided, what is modern to the modern men of action and precision; and what is dead or is not, though you cannot see it, cannot show refusal as insisting, cannot see or show where *listless* turns to *thorough,* and you cannot say what you do not know. That, as is said, an abstract liberty is only abstractly liberating. That, as is said, the material cause of transport is the void. This thinning anything. Can't get spent.

Winter comes. Toppled semis abandon crates of cabbage and tomatoes in the snowdrifts edging the highway and so avoid months of quarantine.

> *Dear Jack,*
>
> *Can't you convalesce with us? Even tho I don't know what we're offering & probably plenty of domestic yappings—But we can try to make it pleasant for you anyway. N's mind truly a blank—(he said: verify it). Wait til that psychiatrist gets going on him! Comona my house.*

•

In the week before Christmas during the last year of my twenties I found myself getting fairly drunk at a bar in town with a friend who suggested we edify ourselves by reading sentences aloud from the three books in my bag while playing pool, alternating cue and paperbacks between shots. Among them was Bernadette Mayer's *Midwinter Day*, which had been written in the year of my birth. I did not mention this, sidetracked in describing her attempts to sit and write out each thing that happened over a given course of time and space in or around her, if this was what a day was or is, and what this seemed to be pushing upon and why it mattered. He said *your problem is you don't know how to read a fucking line break*. Which is true, I don't. There was still smoking in the bars then, and the tip of his ash fell onto a page and made a small burnt corona, which I did not notice for days.

Two years before Mayer writes her book, a small group of Dutch engineers will assemble and publish a *Multilingual Dictionary of Concrete Terms*, which attempts to exhaust the list of words and phrases in French, German, English, Spanish, Dutch, and Russian most relevant to a material that is new but also old. *You must know the nature of concrete*, insisted Louis Kahn, *what concrete really strives to be. Concrete really wants to be granite but can't quite manage.* He added pozzolana to his aggregate mix for the Salk Institute because it gave the material a kind of warmth, as he described it. Reinforcing rods were *the play of a*

marvelous secret worker that makes this so-called molten stone appear wonderfully capable—a product of the mind. Ben C. Gerwick, the president of the Federation Internationale de la Precontrainte, does not get hung up on anything resembling metaphysics in his introduction to the dictionary. He concludes with the sentence: *I am extremely pleased to be introducing this very useful publication to engineers working in the field of concrete throughout the world, and extend a warm vote of thanks to all those who contributed to the successful finalization of this project.*

Invocation and electing, gratuity and confidence; a bland reciprocity marks the language and unction of the highway in any case. Little frictions in the way these things are blended, slight contortions in a president's text, are nothing that cannot be dealt with or named—i.e., *sieve residue* or *Siebrückstand* in the German.

You could paint someone hunting quail or ducks or pheasants. You might depict a game of horseshoes, a traveling carnival, a Ferris wheel or skeet shooting. You could paint pairs of people dancing in the evening, their arms hooked at the elbow, or children splashing in the shallow waters of a creek. You could paint the soybean harvest. You could paint fur traders and covered wagons and the yellow glow of lamplight. You could paint figures carrying thick bundles of wheat or bending over plows. You could paint parades and seasonal fireworks. You could paint the

people circling newsstands or filling cable cars and parks. You could paint their slightly open mouths and their gingham dresses or brown slacks and suspenders and their picnic tables full of food. You could paint the invention of the steam turbine or the sunlight slanting across the steps of the capitol; or T-squares and protractors and drafting tables and handshakes. You could paint town hall meetings or bandstands decorated with ribbons or the shingling of log cabins. Maybe a sunset. A sunset, and maybe doves. Or maybe troughs streaming with coal or the bridge builders pouring water on the wood to make the woven boards set. You could paint the visages of our city fathers or lumberjacks carrying crosscut saws or red-hot slag pouring into open molds. You could paint the pine trees lining the river upstream, where it curves out of sight. You could paint the slow rolling hills or the acres upon acres of rising corn or the full billowing sails of the herring fleet or everything that is ferried and hocked on the esplanade. There are so many things. And you *are* a painter, it says so right here. And things could really be so much worse for you. You might try being relieved that you are twenty-six, with limited connections, and that you are nevertheless not marching anywhere with a rifle or standing in a soup line. Celebrate however you want. You are an artist and you are not dead. And it should have made you happy.

Or

Maybe you could just paint. You could clock out or walk away or be a fool in other ways familiar to you. You could petition for a leave of absence, as he did, and be denied, as he was. You could tell yourself tomorrow it will be otherwise. Sometimes I think Jack wanted to make himself as simple as he could. Sometimes I think his only real question was what it might look like, how it might feel, just to paint.

The first road is the holloway, which emerges beneath the almost aimless movements of animals. It is carved by

skimming and trickling. The first road is indistinguishable from erosion. Its backdrop is always bucolic, a canopy of trees and the calls of birds.

Not ground or figure but flecks left on a post after days and days of rain. Corners caught beneath yellowed tape. That he lived or moved *like a sidewinder* was the phrase; from the panhandle and into Oklahoma, where he had a second family. She never saw him again. If any relatives were left, she said, she didn't need to meet them.

Gravity is the first road. It is a viscous thread, a stem, a shoot, a cylinder untapering. Naming is the first road, the spine, the stray. The many fine wanderings of unattended fathers. The cobble, the stick, the crutch and pith remake the road. As gold, then gray. White-striped black, adjacent to light. As line or tailored crater. The wind that winds around it radiates. It clothes all our uncaring.

You could paint the angle of the ash as it fell, or the near-dead ember's mark, like a small rusting sun, just above the hyphens in *we dream we yell making unheard-of-noises.*

Began by declaiming, *I am asking into adolescence, I am asking does it end.*

Because the dream of paint announcing that *this is really all there is* must happen so definitively, it must be staged

again and again; by Malevich or Ryman and your choice of a third. Since there is relief each time it replies that there will be no such thing, ask again, by other means. As when, in 1958, two years after one version of the story ends, an adorable chimp walks onto the set of *The Today Show* outfitted in black slacks, a white collared shirt, a vest, and a bowtie, picks up a brush, and begins to paint.

Barriers are provided with a coating of white primer on both sides at the factory whilst the top-coating, which is often white as well, is not applied until after final assembly on-site. It is desirable to paint the exposed side an unobtrusive color to match the natural surroundings as they change according to the season. Suitable examples include: gray, grayish brown and olive green.

149

The way gesture is aligned to moments of instantiation and wordless, mythic violence—an act that would only undermine itself by giving justifications or reasons. Was this the hope we had for crowds? An outdated dream of this unequivocal hastening, this surge to claim a world. If this was also spontaneity, how had it been made into such a private asset? Where couples and friends entertain each other, vetting claims to personality. A thing or place to fret over enough to never get right.

These, in combination with strategic use of foliage— what the Germans termed *Die Blendschutzpflanzung im*

Mittelstreifen, herein translated as *anti-dazzle hedging*—will significantly reduce both oncoming glare and consequent instances of temporary driver blinding. *In cases where the crash barriers have been galvanized there is often no need to paint them, as their matte gray finish is adequate.*

And it may be that I address you only incompletely; that I speak of paint when I mean forgiveness, of Teletype and ash and sticks instead of love.

1951. In this year, while Pollock is in East Hampton finding, perhaps, his apex, the state of New York is in the third of twenty-four that it will spend constructing the Cross Bronx Expressway. A task complicated less by the difficulty of displacing the sixty thousand human beings living in its way and more by the pressure of making necessity hover. Because laying such a road meant suspending hundreds of lines carrying water, telephone conversations, gas, sewage, electricity, and rapid transit shuttles stuffed with people, and because these, along with over one hundred avenues, boulevards, and cross streets, would need to keep functioning with some degree of consistency, for years. And so the road grew just beneath them, inching farther into and across the ground you could be standing or sitting on, or walking across with friends, above unseen nineteen-ton girders and needle beams. Robert Moses preferred to call such undertakings *operations*. In the year of *Mural*'s commis-

sion Moses writes an appreciation of Haussmann's vision and an assessment of his failures: *Haussmann knew what the public ought to want, but he did not concern himself with educating public opinion and building up the support which would have allowed him to finish his work.* These cities and their centuries; their rhymes and anesthesia. In an over-built metropolis, Moses said, *you have to hack your way with a meat axe.* Though it was not a blade or metaphor that made the most expensive mile of highway ever built, but lines of bodies finding a route back into an open and unfinished tunnel, dynamiting day after day into the amazingly durable Fordham gneiss that was removed, as one engineer would later put it, *in teaspoons.*

Not size but scale as the question that allows Art to be Art; not origin, but the very possibility of exhaustion that gets lost among objects. How will you frame the ground that binds power to itself or Jack to his gesture and so to his simplicity which is one of small steps, a stick stirring black, little pulses of smoke beside shifting shoulders? The way an arm will seem to be draping something testily, replacing it over and again? A time needs a man needs a market needs a state needs an emblematic anthem of a man to show this rote devotion to impatience. An *is* and *was.* In this, Jack stands unsurpassed.

2010. Vendors circulating in the eighth day of ten within a traffic jam stretching some sixty miles outside Beijing, the

steam or umbrellas, the squeak or glinting or none of their wheeling metal carts.

1958. The shape he made was something like a triangle: white shirt, black slacks, vest and tie. Picks up the instrument. Thinks? Contemplates escape? *The importance of these discoveries for the study of animal psychology need not be stressed here.* The show's human host came to resent him, periodically spiking his orange juice with Benzedrine so that the creature became irritable and almost impossible to control.

Or say he is a gown whose rhythm is glimpsed at a distance and invisible from within like these interpenetrating sways of him.

Described in a prominent obituary as a *bearded shock trooper of modern painting.*

Prometheus, his twin, or their division over purposeful demands; *I opened my eyes in darkness* or *in darkness opened my eyes and eyes behind mine were closing.* The highway is a mediating skin. A place where our long daydream of ourselves might still be sustained.

After he'd had a few, there were things Jack did not mind speaking of. He'd tell you the one about some distant relatives of his father's visiting the Pollocks at their home in

Phoenix, and how the boys were in the back playing with the family axe. At some point, for reasons that never come clear, Jack points to the chopping block with the middle finger of his right hand and a boy named Johnny Potter, who is holding the axe, swings it. The tip of Jack's finger leaves him. A small thing, not an inch from the tip of the fingernail to the creases of the joint. He begins to scream. A rooster runs past and swallows it whole.

Or a figure's claim to *work* by evocation; pulling a roller loaded with pigment across the long flat wall you stand in the shadow of through the morning, moving to the other side of the building after lunch. Your headphones let books and lectures on cassette disappear into you, in parts, the plots of Russian novels largely lost, though you cannot say what it was you were thinking of instead. These *loose, baggy monsters*, as Henry James described them, which slipped so easily over a routine.

1978, a year in which portions of the autobahn begin to have no speed limit at all.

On Contiguity and/or Four Millimeters of Travel

We arrived at Council Bluffs at dawn. I looked out: all. That speed can't you drive a little slower. It started to rain harder. Wearing my standard anywhere. You can always folly a man down an alley. Can't slim boys wander some kind of trouble. Believe exams reach to the world. A kind of toolshack on wheels. Joined the sleeping passengers. For this I spent ninety miles stuck and liable. Counseled deliberately to edge and shimmy. Calling Maw's name from a distance hyaw hyaw hyaw like they do in their livingrooms all over America with all the cowboydudded tourists and oilmen squandered all but two dollars on a rickety

nightclub among the dreamy murmurs and noises of the station absentminded rooking godalmighty the sad music of the merry-go-round and me sleeping in some gilt wagon on a bed of burlap amazed by the simplicity of the whole ride somebody in the wild lyrical drizzling air of Nebraska riding this sonofabitch headed for the harvests winking, singing in the breeze among the hundreds of people passing in a minute just over the rolling distant snows of Estes I'd be seeing old blue air. In there. Being whole. In doorways. In general. Mulled. Half-moronically. Immense sullen restaurants chipped the plains. Lined with minutes. Quickly disconsolate. Short spell sounds like yessir, practising sand and having no reason. Moths on the desert this. Is a big country piss-call. His moods and his fears. A watcher of the night inched to the back of the platform to the music on the jukebox. Was they doing that on purpose. They sure were. Every now and then. So I offered. Wandered the streets I aint beyond doing it you can always folly a man. The company slowly rattled. Passengers go by in a blur. It was just the spirit. Can't you drive any slower. All winter I'd been reading.

What Is a Floor

It is essential, writes Vitruvius, to lay everything upon a plane of consistently compacted earth. Also, that the planks fixed to the end of each joist not be those of an ash tree, or a beech tree or a common oak or a turkey oak, but winter oak, which is the least likely to absorb so much moisture that its warping will come to crack the pavement open. When you have laid the wooden floor, cover it with ferns or straw and spread a top layer of stones, each of which should be small enough to fit in the palm of your hand. Mix your aggregate and lime, three parts to one if

it is new rubble, five to two if it is being reused. Have the workmen flatten the settling surface as tightly as possible before you apply your screed, which will be three parts crushed terra cotta to one of lime, *forming a layer no less than six digits thick. On top of the screed, the pavement, whether of strips of stone or mosaic, should be laid with a set-square and a level.*

A brief mention of *stipulatio* included in the Twelve Tables outlines a proviso whereby almost any agreement can be made into a binding obligation between parties through the asking and answering of questions aloud— i.e., will you pause to gaze upon this work that found and moves through you? That makes you and pulls you apart? Will you notice the commonplace way that hours disappear more quickly when you have tried to do something with your day? What was meant by that throwaway claim: *sensuous particulars, an abstraction?* By *saturating the seed stocks of words?* Rub the corners down until they are even. Rub away each bump and shard from the surface. Polish. Scatter some more of your sand and lime, your marble powder. See how your time can now be stood upon and walked across without you.

What Is Mimetic

In her Pollock biography, Deborah Solomon men-
tions this business with the rooster and the axe somewhat
cautiously, noting that one wouldn't want to make too
much of such an incident. This would be more convinc-
ing if there were a single version of the story. A diver-
gent one has Jack chopping off his own finger while split-
ting a log, still another has Johnny Potter chopping while
Jack clasps the neck of the chicken in his right hand. In
both of these versions, Jack saves the fingertip from the
lunging bird and gets it sewn back on. According to B.

H. Friedman, his friend and first biographer, the rescue was Jack's favorite part of the story. His passport, which he never used, records the tip as missing. Friedman says Jack's story always included a brief display of the intact finger for whoever was listening, and that this finger appeared *scarred and gnarled*, though he also says, without seeming to realize it, that he is describing Jack's index finger.

1925. Miller McClintock, the first doctoral student of traffic, was also the first to link his subject to fluid dynamics, describing vehicles as cork-puzzles in a system of arteries, massing in cascades, shifting with frictions. He distinguished four types of the latter: medial, intersectional, marginal, and those internal to a stream, which are most frequent.

Automobiles themselves he considered *a menace*, the single *greatest public destroyer of human life*.

2010. General David Petraeus is in his fifth year of finding the same analogy to describe American combat abroad. He often presents departing officers with reproductions of Frederic Remington's 1908 painting *The Stampede*. He pats a large print of it twice along the lower edge of its frame before beginning to describe it to cameras from ABC News: *What we now call it is the Kabul stampede—it was also the Baghdad stampede in different incarnations—you can see the rocky terrain and the rain and the storm and the*

lightning bolt and of course he's riding flat out for glory and the brim of his hat is back and so forth—so it gives a sense though, of what it is we're participating in. And it also gives license to great inscriptions.

Prometheus, his twin or the sympathies that lay between them. Cunning or gall measured not by acts of theft but a willingness to make false sacrifice to real gods.

Though he would not wear a beard until late in life, well past those moments held, posed, deemed later to be *timeless*. Rendered to a land that frequently observed his sartorial rhymes with Stanley Kowalski, his kind of not-trying in the de facto uniform of jeans and white T-shirt. Growing round and old and known, making choices in the form of bad hats, some horizontal stripes and gray raincoats. How did it ever come as a surprise, to me or to anyone, that his name was made to shill for khakis? That such total devotion to the present could have no greater advocate than fashion? And that fashion would find Jack so useful, would let his reverence for *now* pass into the status, the fact of *a classic*.

McClintock was also an early observer of what will be formally termed *the fundamental law of highway congestion* by Anthony Downs in 1962. Maybe it is one strange and counterintuitive thing that everybody already knows. That the space created by roads is never really space, because it is

almost immediately filled. That, as Downs will describe it: *traffic congestion rises to meet maximum capacity.* In the cities it would be best, McClintock wrote, almost forty years beforehand, *to give trolley cars the right of way.*

Dear Jacques, J. or Petit Jean,

This is an ardent fan letter. This is late Sunday afternoon—I start out again early Tuesday morning. In these dreams you are not taking dictation but receiving it—quite a subtle distinction, I grant you! Have you eaten your eight hamburgers and are you sitting under an orange tree with your orange cat while pea soup is cooking for you? When doctors give me such instructions, I say to them, "Just what do you think the Presidency is?" I was all alone—(my friend sometimes rides with me. He is Sir Louis Greig, in charge of the Park)—so I could go exactly where I pleased. Pheasants, partridge, wild duck, crows— in one instance being pursued by two king birds—brilliant red trees that I'm told are hawthorns (sometimes the flowers are white) whole massed banks of rhododendrons?? and lovely blue fields that look like bluebonnets to me. I'd like to sit here and write for an hour more; not that there is a lot to talk about, but there is something satisfying about wandering along with no thought of the impression one is trying to create or the logic of the argument one is trying to present. I'm beginning to see it as an infinitely diverse thing, where teacups can hold up a shelf somehow. You said again that the child was the master of roads. You said

161

there was a cabin in the mountains. There was a secret way you got in, underneath the boards, under the windows. According to him I knew all about the theatre and drew a fine line. It was a magnificent cabin. He was into Proust for quite a while, but he was just jumping from one thing to another. I didn't otherwise believe in predestination. He disemboweled the inhaler's casing in front of me. He pushed down the end of his nose, which appeared to have no cartilage. Show me the city with its ragged edges hid. Abstraction and its open secret. I opened my eyes in completion of the night. Those were the roads we spoke of. Some words he said over and over, in variations, because they could not please him. Jack liked the sound of lonely and alone, in particular. I once loved a woman who taught me everything. Find a way or make one. Inversions or a hex; not figure, ground or Rome but Jack cellophane shrink-wrapped a world unavailable to touch and yet built into you, a world arranged in horses' hooves.

Promethean fire is not the fire of a god, not the fire of heaven, not the fire in the lightning Zeus handles and scatters and tracks, the lightning that is immortal and ever-ready to crack across the skies or the window, ever-ready to be thrown into open swaying ash trees simply to show that *this nothing, this is endlessly available.* A Promethean fire perishes, will perish. It is wavering. It is created, hungry. It is kept or is not. It is carried in the hollow of a fennel stalk.

•

A belief in one and the unceasing impossibility of one; in blood and/or farm animals. Allegory or atrophy. The present-archaic, and the future, archaic. The never-to-be and the already-begun. To arrive at the trial requires all sorts of tooling. A story plays its moments through.

The one about his would-be best man coming to him in the morning, saying what had happened.

The one that will include the name of Edith Metzger. The bag she packed for the weekend.

His questions about what happened to the pocketknife.

Her position as the receptionist of a beauty parlor.

Jack said that Lucien said that Bill said to call a goddamn lawyer. It was August and they were practically children. They spoke of what to do. Then they had an afternoon. Caught a movie, ate hamburgers, walked around inside MoMA for a while. Went down to the river's edge and he showed him where he'd weighed the body down. Jack Kerouac, twenty-two, pled successfully not guilty to being an accessory. Hadn't even been there when it happened, he said. Only talked to him after. Only watched him bury the glasses.

Fort Benning, where the School of the Americas will open its doors in 1946.

•

Dear Jack, you move with the exigency of someone always under attack. You admire the way they *set fire to the grass around the animals except for one passage left on purpose.* You say this is sacrifice but this is nothing, Jack, nothing but bones and fat.

He rewrote the title *A Road as Long as the Night.* Wrote out *I Wonder Where the Road Ends.* He thought about calling it *Rockbelly Road.* He wrote out the title *Moaning Road.* Wrote out *Go Moan Man a Road.* Wrote *Road, Go Moan a Man.* Jack tried out nearly a hundred variations of his theme, some on scraps and receipts, then a few dozen on the empty under-side of a spreadsheet for expenses and inventory, scratching his pen across the faint mirrored outline of its grid, across the blank boxes labeled *Employee Number, Name of Account, Project Office Salaries, Central Office Salaries, Janitorial Expense, Structures, Painting and Decorating, Plumbing and Gas, Electrical System, Community Activities, Refrigerators, Maids, Exterminating, Refuse Removal, Watchmen, Heating, Grounds.*

A sandpainting begins and ends in a relation, occasioned by sickness. It makes a place of passage, a portal. It is formed according to the codes kept among tribal singers, then pressed into by the stricken body, which sits and is chanted to; and the deities that are called irresistibly by their likenesses upon the surface beneath the body may cir-

culate and be placated by offerings from the patient and singer as the latter places bundles to the body parts of the gods, then touches parts of the patient's body to his own— *foot to foot, hand to hand, shoulder to shoulder in the ceremonial order.*

I read somewhere that our ongoing preoccupation with trauma cannot be separated from an increasing doubt about almost everything else. This may or may not be another way of saying that All We Really Want is an Event. We want the idea that what is shocking and painful makes a place we can see, a proof that what changes us irrevocably cannot go unnoticed. Trauma is an envelope, a way of arranging the day. Witness the indexical accounts of recurring bird and beak shapes in his paintings, drawings, prints, and sketches, though we might just as viably say that he had probably never seen himself bleed so much before, that in this he glimpsed, perhaps, a fantasy of fluid falling in speckles and ropes from a body that somehow remains standing while life pours through it. A body that cannot be overcome. This is not a sham, exactly, but a story, and it was the story of what happened that he played with. If every version of it remains crudely terrifying and overdetermined it is only because Jack had a taste for such things.

Dear Jack,
Please don't consider this a fan letter, I mean what I say.

•

Adolescence demands risk as a kind of absolution. It must often have occurred to him that perhaps *he simply wasn't an artist at all*, as the great and acclaimed poet and critic pointed out in a lecture at Yale in 1968. Pollock's was an art of *tremendous excitement* precisely because it was pursued at *such terrible odds*. His act was tantamount to everything remaining so open or possible or still to be done or it was absolutely nothing: *random splashes from the brush of a careless housepainter*.

To be renewable and/or interminable, what-this-old-rag or pleased to pander.

Patton, his persistent intuitions. Who sometimes intoned Rupert Brooke after dinner and predicted his own demise in a foreign land though, like all who imagine they are real men of sympathy, he would see nothing human as truly foreign to him. Who saw his life as coterminous with war: *I fought and strove and perished / Countless times upon this star*. Who wondered aloud, in verse, if he hadn't stabbed Christ *in His sacred helpless side*. He had hunted mammoths, had fought Persians as a Greek hoplite, had been Hannibal.

The most generous act offered posthumously to Kerouac came from Alice Notley, who is mentioned several times

in *Midwinter Day*. During that same year, a little less than a decade after his death, she sits and waits and makes her voice a channel and Jack restates his case. He says his work was all a single rounded word; that he *began as a drunkard & ended as a child*. That if life and work could reduce back into one, *I began as an ordinary cruel lover & ended as a boy who / read radiant newsprint*, began swollen and cowed and ended *as a perfect black-haired laddy*, began *in a fatal hemorrhage & ended in a / tiny love's body perfect smallest one*.

Painting a building is an imitation of no one having been there. The inconsistent pressure of your arm is the obstacle of this outcome; the dissipation of paint as a roller is dipped and dries out; uneven splotches emerging into a jagged trellis.

2002. A neonatal macaque is also an adorable thing. Its irresistible scrunched features and tiny pink tongue. Irresistibility is the object each crowd is the ghost of. The seams and relays that fold between us have names, we're told. And homes. Mostly they are in the ventral cortex. They will be lit with a dye and shine orange, blue, or green upon screens and monitors. They are premises or claims indebted to the oft-cited experiments wherein the pattern of firing along a specific set of neural pathways while a subject *either* observes *or* performs a given action

or task—pouring juice into a glass, snapping sticks with a thumb and forefinger, placing a peanut into the mouth, etc.—will prove to be, in fact, the same. And these, for reasons already stated, are named not *visuomotor neurons* but *mirror neurons* by the men in Parma.

The Promise of Being Taught

If you are trying to evoke something vast with a fair degree of quickness, something as huge and variegated as a city, you must find a way to become something else while not sounding entirely inhuman. You must find and ride a particular pattern or transfiguration that is encompassing and fleeting and make it your conveyance.

In an early draft, Jack lifts from Dickens, who begins *Bleak House* with a desire to see further up the Thames River, *where it flows among green aits and meadows*, then back down to the London docks and *into the cabooses of collier-brigs*

and *the eyes and throats of ancient Greenwich pensioners* and into *the stem and bowl of the afternoon pipe of the wrathful skipper* in his cabin, where the sooty fog seeps beneath the door and across the creaking boards above him, *cruelly pinching the toes and fingers of his shivering little 'prentice boy on deck.*

On April 27, 1949, Jack plays the dutiful pupil, replacing Dickens's fog with a disappearing sun. Two weeks earlier the moon had turned crimson over most of the country in a total lunar eclipse, but the time Jack writes into his blackbound notebook has none of this; it is encompassed by the deep red sunset that falls across the city and the *wallsides of high buildings which suddenly shone feebly in the big light that was like the glow of a golden rose* and people raised their heads and swiveled them and smiled; *in the morning it had rained some: but now the dull clouds were empurpled and made to flame at the borders,* and *all over New York this lovely, otherworldly light hung haunted between buildings, in alleys, in deep streets over the soft tremblings and glitters of Times Square,* across Fourteenth Street and Borough Hall in Brooklyn and *over the darkling waters by the piers* and the spaces where *the narrows softened by Staten Island to the night seas, over the buzzing hums, the great ruinous neons and rooftops of Harlem and the East Side and over the millions of people* who will remain unnamed because they are not where the light is going. It is going to Rikers and to the *gaunt* and *burnished* face of Red Moultrie, who has almost nothing to say and so the draft drops off.

On Method

1964. In early September Ike gets a letter: *For the past six weeks I have been reading your World War II correspondence and feel I am getting to know you intimately; therefore I think it only fair that you have the opportunity to see some of my writing.* While awaiting a response Stephen Ambrose taught history at Johns Hopkins and kept at the letters, copying out phrases, arranging his annotations by date, place, or recipient. His first book about Ike will be published in 1967. Six more will follow. In May of 1998, a few months before the last one is released,

he is interviewed in Jackson Hole, Wyoming, by the Academy of Achievement, a D.C.-based nonprofit organization focused on *sparking the imagination of students across America and around the globe by bringing them into direct personal contact with the preeminent leaders of our times*. Ambrose answers questions about growing up in Lovington, Illinois, about being a middle child, about the importance of Latin in his early education and the vastly more consequent choice of verbs rather than adjectives in any given sentence before talking about his writing more generally. And about Ike, who actually called him personally to ask if he would be interested in writing his biography.

He remembers saying yes. He was twenty-eight years old. His first book, a study of Lincoln's chief of staff Henry Wager Halleck, was published in an edition of two thousand. He remembers saying, *Yes sir, I would*.

And so was flown to Ike's retirement home in Gettysburg, where they spent the day talking about everything that would be involved. And when Ambrose inevitably asks why him, Ike says he read the book on Halleck.

The interviewer asks him if he had recognized Ike's voice when he picked up the phone that day. Ambrose says of course he did. The interviewer asks him how he felt. He says he felt *ten feet tall*.

The interview is one of several in which Ambrose claims that during the last two years of Ike's life he met with him nearly every day, that he spent *hundreds and hun-*

dreds of hours interviewing him. Over the course of a three-hour conversation Ike's eyes would never leave him.

During the decade after Ambrose's death in 2002 it became increasingly clear that most of these conversations did not happen. Ike was exceedingly well looked-after at Gettysburg; each of the visitors, letters, and phone calls that came into the home was logged by a staff led by Brigadier General Robert L. Schulz, who served as Ike's executive assistant. According to these records, Ike and Ambrose met three times for a total of less than five hours and were never alone together. Seven of the nine dated interviews that Ambrose cites in *The Supreme Commander*, his first large-scale work on Ike, were imagined conversations. Subsequent books cite interviews with no dates at all.

You Must Instruct My Ignorance

1928. McClintock goes on record saying that the *automobile has brought something which is an integral part of the American spirit—freedom of movement*. He has been hired as the first director of the Albert Russel Erskine Bureau for Street Traffic Research at Harvard, a bureau founded and exclusively funded by the Studebaker Corporation. Addressing the Society for Automotive Engineers, he speaks of cars and roads and the *inevitable necessity to provide more room* for their liberty, which is ours. He predicts that within the next quarter-century the country's

traffic problems *will be solved to the satisfaction of the public* and derides these traffic engineers who seem to think they're living in an age of *whip-sockets and dashboards and hitching-posts*.

It was not the photographs that finished him, we've been told, but the film footage. It was a gleaming clear and very cold day in late October of 1951. Hans Namuth had begun taking black-and-white photographs of him painting during the previous summer and says they built up a rapport. They spent that afternoon trying something new: Namuth with his camera rolling, poised beneath a clear sheet of glass Jack placed atop two sawhorses he had built for the occasion. The idea, Namuth said, had come to him in a dream. Jack scattered pebbles and arranged pieces of wire mesh, then began to pour, then quickly stopped and in the narration later added he said *I lost contact*. He began again and Namuth got his shots. They went inside and Jack poured a bourbon for each of them and Namuth knew it had been a year or two and said not to be a fool and Jack said any number of things as the evening went on. It was a bad night for company. A dozen plates of roast beef were strewn across the floor after he turned the table over. Lee remembers announcing loudly that coffee would be served in the living room and he slept at home that night if he slept and he did not get sober again.

•

1954. The first president to make use of a teleprompter, Ike mostly hated the damn thing. It was like being bandaged into your own imagined voice. *Just let me get up and talk to the people,* he told Robert Montgomery, who starred in *Private Lives*, *Night Must Fall*, and *Ride the Pink Horse* before becoming a television consultant to the White House. *I can get through to them that way.* In early April, Montgomery directs him to stand up and walk away from his desk, then to sit casually on its front edge while speaking about the hydrogen bomb.

The painting of self-evident nomination unfolds as *I is I is I is I.*

Whirring gradually away in the chain, uncurled in calm sequence; innumerable transparent tissues hovered in the round.

A *love-hate affair with edges, an urge to ignore them and get beyond them at the very moment of coming to grips with them.*

Merely to imagine them is enough. Bathed in a sufficient flow of overhead light. Nothing very miraculous.

Montgomery, a former mid-ranking officer in the navy who testified to the House Un-American Activities Committee that he had become aware of *a very active Communist-front organization* within the film industry during the late thirties,

was specific, firm, and distractingly handsome. He *gave the president complete freedom with his natural gestures, including his trademark impulse of folding and unfolding his arms.*

We get in the car and roll backward, placing our hands to the slotted air coming from the dash. The news cycles through the radio and turns over. We edge closer to where the land becomes driftless, a swatch of light turning tangerine on the smooth rounded hills coming into view. I do not know why I am intent on asking how it would look or feel to you—the highway, the sun, the color of the sunned earth—if you had been standing all day beside it, swiveling with a shovel beside an armed guard.

The trademark impulse of art and statecraft: to square the circle of the many and the one; to make a surface that could weave these into reversible terms. *You are too close.* The charge within a gesture that precedes signification— was that what each of them was looking for, before the guard stepped in? To acquiesce to the simplest things in him; lavish fractions of a lift or glimpse postponing the moment in which we concede to become only our small and terrible selves.

Something is new and you do it again. Not holding but grasping-after. Jack sick and pissing in Peggy's fireplace. Jack shining and bloated on the couch with William F. Buckley. Go east. Take another lover. Grant an interview.

Repeat. Move home to your mother. Drive along the shore-line, slow as a crab.

1952. Though it was not Jack's body but Neal's that had to disappear for a script or myth to emerge. Plenty of admirers who wandered into his life mistakenly saw the character of Dean Moriarty as Jack's stand-in. John Clellon Holmes, who is often credited with coining the term *Beat Generation*, was among those who didn't mind pointing this out. He described Neal as *a marvel*, though also, *in the traditional and most rigorous sense of the term*, a psychopath. Mostly Jack's fame was a matter of misrecognition. Mostly everyone knew this, or split the difference; or didn't worry the particulars into dust but rather basked in the glow of a proximal god or satyr. And how much could it have bothered him, really, to be mistaken for his animating fantasy? Probably it felt wondrous. To be suddenly so talked about, such an insatiable curiosity for so many. Wondrous that you could buy your mother a house and basically forget about your failure to land a gig as a brakeman. Wondrous that everyone in the room would now like to buy you a drink or take you to bed or both. Made him feel like the mayor. Though before he was declared a spokesperson for the spirit of an age or generation, Jack was a houseguest, waking on the first morning of the new year in the attic of Neal and Carolyn Cassady's San Francisco home. He is happy there, for a while. During what remains of that century, roughly half of the planet's oil will disappear.

Afternoons, he is typing, getting high, staring out at the treetops speckling Russian Hill. In the attic, Jack can play acolyte to the boxes and piles of Neal's personal effects. They are scattered so close to his sight, he cannot help it. He nearly blurted something like *Dearest Neal, I want to roll around in your clothes*, but decided instead to write out the name of each thing he could see there, resting on top of the wooden floorboards: *his workgloves, dungarees, chino pants, shirts, socks, shoetrees, cardboards, white shirts piled on top of ancient leather belts, ancient railroad overtime papers now stomped with the dust of shoes.*

And though gods upon the surface of a sandpainting may be portrayed alone or severally and ceremonies may occur once in the course of a two-night sing or successively over the last four days of a five- or nine-night sing or once at the center of each day during Holyway ceremonies or in the middle of the night, as part of an exorcism, what is common to each sandpainting is that it must disappear. It has become absorbent and, in healing, toxic. It must be erased line by line, reversing the sequence in which they were laid down; a system of speeds and slownesses; a composition made by many small acts of unholding; each line unpinched with thumb and flexed forefinger, retrieved one by one; these flecks of sandstone, charcoal, pollen, cornmeal, powdered flower petals; in heaps, deposited north of the hogan, beneath the branches of a lightning-struck tree.

•

Jack Kerouac, just over forty, on a bus from Lowell to Manhattan, favorite bottle of rotgut between his knees. Maybe even a little keyed up at the thought of a night away from Mémère, bless her. Was due for one, at least. He will end up asleep on David Markson's couch, decades before the latter will copy out a note about Clement Greenberg, the early and decisive champion of abstract expressionism, refusing to deliver a eulogy at Pollock's funeral, disgusted by Jack's last act. He could not say aloud what was obvious: that it was better for Art that Jack was not the lone survivor of the accident. Imagine the terrible jokes. The verbs they'd have had to work with. The unseemly, flagrant fact of him persisting.

And in Lagos, where the burned-out wrecks beside the highway are left for weeks, sometimes months; waiting, sometimes, to be entirely covered with advertising posters.

Not the beatitudes, but Milton Friedman who will be quoted approvingly in Jack's last notebook, alongside stray jottings for his last essay, "After Me, the Deluge."

Ike said very little about his father. His other sons describe a man with a temper who was also fairly cold. *An inflexible man with a stern code*, he lived *soberly and with due reflection*. They woke before dawn to start a fire for his breakfast. He did not swim or fish or hunt with them. He had

little to no interest in what they did or who their friends were. After the family stopped meeting with the River Brethren, he began drawing large-scale renderings of the Great Pyramid of Giza. Biblical prophecies were foretold in their designs, he had decided. Though numerology did not require a particular quota of these drawings, only that he keep making them. Generally they were around ten feet tall and as wide as the span of his arms.

Jack as the avuncular gloaming nomad. As the early and quintessential Old Boy. Will we prefer the phrase *mystic expiration* or *illustrative annihilation*? *Everyone who has talked about the day's events*, Friedman writes, has emphasized *the penetrating cold*. Namuth says that Jack was at ease with the film until months later, when recording the voiceover.

No one asks why their stories of him must recapitulate the corruption of a noble savage by the camera. It is possible that, up until then, he hadn't realized he was doing porn. Or how out of his control this motion was, not because it was replayable but because it was social in spite of him. Because it was social, it carried every kind of possibility within itself. Because it was also inchoate, it remained paradoxically pure. An intimation. It matters that Jack happens on the level of gesture. It makes a different thing of him or makes him such a one among many inescapably in the middle of making many different things, needing and letting himself

be seen needing and both serious and ridiculous, nearly pirouetting, unafraid of being pretty though he did not know it, unabashedly for himself and for others, a master and an instrument, a countervailing idiot, showing off and hailing and batting at the air, almost praying, looting what he was or could be and trying not to die and being all at once a variable, indefinite sense of exquisite repetition. A figure between glass and sky, impeded.

The highway as a kind of robbery. The highway as a register. The highway as an adjunct to the family vacation. Things about kinship they cannot tell you because they do not know.

Dear Jack,

You might be getting tired of this. In this, we are the same. I want to say I am nearly through with you, or that the reverse is more true. I take what prevents me from sitting in an empty room. *There are two reasons for this. In the first place, you are about my oldest friend.* I decided I was entitled to whatever excess left. Or what fidelity could construe. I wanted to say that there was almost nothing else to do, that you could not be helped or didn't need it. Or that you were so determined to remain open to the event of writing, so afraid of growing ossified and shiftless to yourself that you made your work a perpetual rehearsal. I thought I knew something about that. I wanted to ask about the box of snapshots they brought me. And the pose

you made, clowning after a day at the beach. The way you kept your grimace taut beneath the thin towel-as-kerchief pulled flush with your hairline, edges brushing your newly pink shoulders. The caption in pen, which read *Immigrant Refugee*. And the date, which read *1946*. Then the innumerable shots of you holding cats, growing old without growing wise, severe in a checkered shirt, overcoat and cap, pouring wine at Thanksgiving, mother looking on, pensive hand at her mouth, black ironwork railing, its shadow—tell me again how I should hold these things. Or what it means that writing can only begin in emulation. If yours became a kind of long loopy patter, it is only because it had to. That was the claim, at least. I cannot say if I believe it. I will not write to you again.

183

 yours,

 R.

Frank O'Hara, in the first monograph devoted solely to Pollock's work, declares that *Number 29*—the painting he completes above the camera's eye—makes Duchamp's *Large Glass* look like *mere conjecture, a chess-game of the non-spirit*. He loves the way that, whether viewed from front to back or vice versa, it was *the same masterpiece* and revels in its bracing play of texture, flash and futility, *the brilliant clarity of the drawing, the tragedy of a linear violence which, in recognizing itself in its own mirror-self, sees elegance, the open nostalgia for brutality expressed in embracing the sharp edges and banal forms of wire and shells, the cruel acknowledgement*

of pebbles as elements of the dream, the drama of black mastering sensuality and color, the apparition of these forms in open space as if in air, where each piece of anguish and escape might still turn back on itself, where the contingent and the self-same will confront one another indefinitely. These things are frozen. They are freighted, sagging schemes. They are made in abeyance. So much like the living. If it is true and unverifiable that something ended that afternoon or evening or in the days and weeks ahead, that a tempestuous, glib, and wild singing left him and he never got it back or never wanted it again, then it is equally true that as we watch him performing, watch him waiting to see how it plays out, these are always things that *will have* happened. If Jack's practice tells us that we are simple and rude and we can do anything, its capture, which is viewed in the future anterior of all consumption, must affirm what we already know: that freedom can mean nothing without being viewed, then envied. Lots of Jack's paintings contained something of their time, as O'Hara wrote, *with valuable elements of other eras revalued, but* Number 29 *is a work of the future; it is waiting.*

Jack or the Spirit of History on Horseback

A last essay made mostly of grievances; of sad and hissing bluster. The horse, a creature or instrument decisive to conquest; whose wounds were often dressed with fat shorn from the bodies of slain natives. What does it mean that initial impressions of its approach, those moments it made as it came across the continent, will resist any attempts at representation? A galloping horse and rider in full regalia, repeatedly perceived as a single creature: How would you render such terror? What is the point of asking? Or conceding that the real is defined by its impossibilities; is riven,

is pocked. What was it he wanted from that phrase: *end of land sadness*? Then the interlinking, persistent and contrary feeling, when writing, that there could be a moment for everything; a time to quote Heidegger, a time to quote Juvenal, a time for Donald Phelps and Andy Capp. Why, in his last essay, did he close with the latter, a British comic-strip character? How easy would it ever be, really, for Jack, to see himself, his life, as parody? Or was that what his title sought? To be the end or culmination of *something*, surely, if not the Great Man of secular myth then the beleaguered forewarning emperor. And did this come to the same thing as his need to see or show how every poet bears within himself the ruins of a notary? He typed out a list on the back of his page, most of which will be included in the final draft. A way to prove he knew exactly who would attend the fundraising dinners of *activist Yippies and SDS'ers*; not the names of things that made him flush, but the tedium of titles: *House Appropriations Chairman, assistants, Health Directors, Commission Chairman, assistants, Assistants to the Director of Regional Planning, Neighborhood Center Directors, Executive President of Banks, Chairman of Interior Subcommittees, Officials of the Department of Rehabilitative Services, Planners of the Preliminary Regional Plan, ethical Members of Rules Committees, House Insurance Committees, Utilities Commission Entrepreneurs, Expressway Authority directors, county news hacks, spokesmen, pleaders, applauders, xxxxxxxxxxxxxxxxxxxx aides and wives of organdy, $2500 worth of food and $5000 worth of booze and the caterer's cut*

thrown in, for one "lunch," tax-exempt, televised for a 15-second spot on the evening news to show how well they can put on the dog. What was it that inhered in that word—*phony?* The way it became so indispensable to an era. The chance to feel so unassailably real when wielding it; fulsome, accusatory, palpitating. Why give over so much of your last notebook to fuming about Ginsberg and his "Unified Theory of American Prosody" *(which is my invention) (the theory that is) Which is saying anything you want to say at the time you want to say it, in the way you want to say it, <u>in the field</u> (under a line) o pfrrt oo.*

The last syllables show something Jack reached for or resorted to increasingly toward the end. Not from any interest in or tribute to Hugo Ball, but as a way to show a willful overflowing. The barest insouciance. An act of discard, not pleasure. There is no real pleasure in becoming an ogre, but an immeasurable amount in remaining a brat.

A rebellion entirely absorbed by individuation was Jack's, a wish of making wish original. A wish that begins and ends with saying again and again what you want, exactly when you want to. This wish was granted. Thus the chance to spend years making bound titles from first drafts. Then the problem common to fame, as each thing he touched or pulled a pen across, held in his pocket or pressed to his brow, became valuable, charged. Living inside the soft factory of his legend. No wonder he felt besieged.

•

Spinoza defines the devil as the one furthest away from god. For this reason, he will be unfathomably weak and pitiable. We should not fear him, but pray for him, Spinoza says. If we must live with imagined solutions to actual problems perhaps this is one way. If it is reductive to say that permission became Jack's obstacle or that a land fell in love with certain romantic theories; with abandonment or freedom or the need of such a one as Jack, who became and remained most believable in his doubt, in his cracked and ruined face in half-shadow beside his mother. Some sad little slob. Kicking around cinders, obsessed with regret. Afraid to stop talking.

Jack and Jack, then; at each end of a quandary in speaking, sign, or silence. Wanting, at once, both a saturation of chatter and an action or stain that would end Art at its outset.

Not Art but the needful, serious thing that remained somehow capricious. Or extraneous.

Not news but the terms that enabled our travel with the promise to fall almost immediately away. The *resistance à la traction par fendage* or splitting tensile strength; the lattice girder or *Gitterträger* offering us up like acolytes to a movement that induced us to believe or repeat the words in their arrangements and columns and forefronts imagining we could remain true to one rage, *avant* or *arditi*.

•

Since the question of the highway is now no longer *why does it exist*, but *why does it not exist everywhere*?

1965. On October 7, while Ambrose claims they were speaking at length in Gettysburg, Ike was being driven from Abilene to Kansas City. Before the month ends an underground nuclear test will take place on Amchitka, one among the archipelago of Alaska's Rat Islands. Plans for this test began under Ike. Nothing about it will be made public until March.

In the memoir David Eisenhower completes in 2011 Ike is *Granddad* and he slows while holding to a routine: he answers letters in the morning, naps after lunch, and sometimes likes to paint at his easel on the sunporch. Painting provided him with *a handy excuse to sit apart from the constant activity on the porch while remaining close enough to monitor; it still relaxed him, permitting him to experiment with color and texture and to satisfy his compulsion to observe*. In North Vietnam, Ike observed, we were not bombing enough. *We should not base our action on minimum needs but should swamp the enemy with overwhelming force. We should err on the side of putting in too much*, he had insisted that October. The United States was *not going to be run out of a country we helped to establish*.

To My Keening and Simple Interlocutor,
 The rest of your attempt keeps looking around for some pre-built villain with this contained, undignified straining

that is hard to watch. For instance: not waiting but a maintenance // of waiting; not typing but / interfacing walls *tells me that you've nearly bottomed out. Or* believing he'd arrived into the end of a century of convalescents *meant:* No, *I* am the little king of unanchored purple glories, *me. I am the disabused internal censor, the unremitting elegy for great dead men. I rode with the indispensable disgraced philosopher through Chartres and held the steering wheel firm, crossed the steady dividing line and remained in the opposing lane as they struck my shoulders with their little hands. To further illustrate my point about anxiety as the floor of our being, I pulled out all my teeth and replaced them with paper. Do not interpret or accept my act because I am your need to do so. I am the imperative to express yourself. You pare away and water down what was so good in me. The last to do something with everything, they said. The last walking catastrophe. I was the shaking and smoke and chaotic jingling of bells that preceded even the Notion. Trampling the slant wind, they said, like lulled music.*

Gesture refuses decoding. This is its promise. To be insoluble and yet transmitted. Line cleaves and totters. Line fends.

The question of art and ego remains: *Who will preserve me? Who will continue to speak my name?* The one arrayed in red, its blades and beveled jaw. The one describing the face of

David Kammerer. The highway as this thirdness between them. We can speak to it as we like; say the names of anything upon it, however we want, since its only refrain can be *follow me*.

On Revision

1961. He began a paragraph in one of the earliest of the twenty-nine drafts of his farewell address with the word *Elsewhere*—and he wrote of emancipation movements and *the concept of equality among nations which, for the first time in history, has come to be recognized as a basic principle in international affairs.* He began the next: *To the concept of juridical equality, with justice for all, we of the United States have subscribed our ardent support. This is one sure ingredient in a total program for world peace; for without true justice there can be no genuine peace, and without equal-*

ity there can be no justice. He sat and he typed these things and looked them over as they lay on the page, and then there were minutes, or hours or days, and then he put a pencil to them and then he struck them out.

What Is Approaching

2010. And in the province of Sindh, where flood sur-
vivors remained without food or drinking water and
camped along its bare medians beneath tattered plastic,
then walked en masse toward the traffic that came in five
lanes, away from Sukkur. Some had sticks. Some set small
fires. Not looking for a polling station or a representative
but a way to make one speaking flinch, to speak the simple
as malfunction: *we, too, exist.*

Before firing at a mob, Patton wrote in 1932, *warn them of
your intention and tell innocent people to "beat it." . . . Should*

some orator start haranguing the crowd and inciting them to violence grab him even if it brings on a local fight. Small fights are better than big ones. Words cunningly chosen change crowds into mobs. If it is not punished instantly after accomplishing some minor feat, such as the destruction of a single patrol, a crowd or mob will gain a false sense of its own power and grow more dangerous, he explains. You must try to *arrange your axis of approach so as to drive the mob into the poor quarter and away from vital areas.* You must remember that *gas is paramount.* You must remember that while *tear gas is effective, it should be backed up with vomiting gas.* If gas fails to move the mob, *open fire with one man per squad for a frontal attack while, at the same time, have men previously stationed in nearby buildings shoot into the rear ranks selecting apparent leaders.* And: *If you must fire do a good job—a few casualties become martyrs, a large number an object lesson.*

Dear Fable,

I often imagine an outstretched hand above the fields of sheared corn as we pass them in my fine automobile and the feel of grain swaying or the bristle when it is gone feels like mine, when really it is yours. And I know this and will give it to you. I will use a word or send one. Maybe night *is never really* night, *is never night enough. You modified it, almost always, into* the American night. *To make it titter? To make it flush? You placed* ancient *across anything older than a window display. The night or its revision, line or its integument entrained thee in eternal whiteness unremitting where thou usest one as thy flute, where*

thou makest one thy eyes, thy ears, where thou makest one thy mouth, thy jaw. Thy canticle, dear Jack. Repetition is our terror at disappearing. Do you understand? Will you accept? Nothing is older than the night. Should you decide otherwise I would hope that the existence of this suggestion and this letter will remain confidential. For this reason, I have marked the letter personal.

Jack Kerouac had plenty of jobs for a day or two. He was a soda jerk and a switchboard operator. He was a busboy at a summer camp. He worked at a rubber plant and a cracker factory. He was a night watchman and a counter of ball bearings and a tire-hemmer and also, of course, he was briefly among a crew of men with shovels digging the foundation for the Pentagon. Mostly he liked to have no job at all and mostly he managed not to. The refusal of work may or may not be the definitive contest to be found in adolescence, or elsewhere. You may or may not consider it petulant or ridiculous, or capable of brushing a potential that is decisive and therefore frightening. You may or may not find something persistently delicious in the act of quitting. I think Jack loved that feeling. It was familiar to him, at least. He also quit the Columbia football squad, as is well-known. It's part of the legend. He had disappointed them by returning to the team slower and skinnier after breaking a leg during his first season. He walked off the field before practice began and dropped out of school and made his way to a flophouse in New Haven and it went on from there.

•

1969. *O new world!*—*Yay, if joy were proponent of coin, what grand economy. It's much like what do you think a parasite is thinking when he's sucking on the belly of a whale or the back of a shark?*

When my maternal grandfather died I found it suddenly impossible to stop thinking about my decision to call him five years earlier. Not the decision, but the impulse or demand that was there, or the thing behind it. We hadn't spoken in years, maybe ten. Maybe less. I sat quietly in cars and planes and stood near a door at the viewing and thought of the stories others had told about his body in a tin shed in Bulgaria during the war, where I was told they had tortured him, off and on, for months. The sound of falling bombs reverberating within the walls destroyed most of his hearing. I do not know if I can call it thinking. I do not know what begins or ends with one body. The sun was out as we walked uphill after the funeral and I felt weightless and somehow radiant and ripped to pieces and the feeling was that these were shaking, lit. He picked up the phone after the fourth or fifth ring, and said the word *hello* and after a while he repeated my name. Mostly he repeated the word *hello*, then the phrase *I'm sorry* and then *I can't* and *please*, and *my hearing* and *please* and *I can't* and *I'm sorry* while I was screaming into the cell phone of the friend A. and I were visiting at Carnegie Mellon and eventually the line went and when I called back no one picked up. Or he had unplugged

the phone. Or fallen asleep. Or he walked out into the yard and lay down for hours. Or I never called back.

2008. Then it was spring and then summer and then there were days and days of rain, so thick and steady and consistent that the light barely came at all and otherwise the days were the same, returning from gray to black and sopping. The radio spoke of floods and numbers, of one hundred and then five hundred years and the thing about concrete is, it does not soak but provides a cover, so that water might slide across its surface, almost indefinitely, sometimes for miles. And so the rain-swollen river rose and spread and came across the land within view of several cameras; and its progress could be marked by a series of large unlit signs upon plinths as it passed them, advertising auto parts and tacos, photocopying and buffets, until its edge came to rest, stopping just a little bit short of the twice-painted building on the Coralville strip, a twenty-minute walk from its banks. Not that I was there for any of it. I had become a student again, taking up a chance for cheap travel and summer credits. I thought nothing about that building as I looked through the online slideshows compiled by our local paper in a café near another shoreline, thought nothing of it as I stood at the foot of a memorial in Rovinj, incised with near-identical silhouettes of soldiers and bayonets, since I was thinking instead about that painting, and of Jack. And as I stared at the *danse macabre* stretching across the walls of a chapel in Hrastovlje, and read the wall text about Pula's

inclusion within the Peutinger table beside a spare, reproduced image of the relevant inches on the document, I thought of it again. A world appearing to us in the terms of our obsessions refuses to be new. Believe me if you want to, I will admit that I was thinking of it while uploading overhead maps of the water's reach. Not the washed-away trailers or the chemicals in its current or the people filling sandbags, not the ruined crops or the accelerating water cycle or the ruptured roadbeds that might make it impossible to get back into town after flying into Chicago. Not that, but the museum in the floodplain and the two hundred pounds of paint and stretched canvas inside it. Forgive me. On the telephone I was told it was the first thing removed from the now-ruined museum. The sun is shining in Rovinj and we buy gelato and snacks from carts along the water that call to us in English; at dusk the bats and swallows mingle as they swing through the air in search of insects. My flight leaves from Trieste without delays and I make it back to town exactly two days after the river crests.

Kerouac relied on a portion of his mother's paycheck until he was well past thirty. Most of her working life was spent at a shoe factory in Lowell where she sat and pressed leather into the blade of a skiving machine. Her fingertips grew dark, then darker, as if scorched. For years, she had been telling him he should try selling insurance. A skiving machine has tangible goals. It proceeds by binding one surface to another.

Not to Scale

In the dream of New York, we live in coldwater flats with weeping larks on the rooftops, dark stairwells and eccentric neighbors and friends who sustain us with their fascinating conversation. In the evenings we look for silhouettes in balcony windows and near-strangers to lead us from the street into the crowded loft where everyone is dancing. Something like this may have occurred. We know this much: four years before Lee heard that she and Jack were in a group show together and decided she should walk to where he was living, they happened to dance together at

a party, and perhaps it was not entirely otherwise. Jack was a crummy dancer. We know almost nothing about initial impressions because he seemed later to have largely forgotten the evening and she generally preferred the story of first walking into his studio and falling in love with him and his paintings in a single moment. We know nothing of Lee's facility with dance or how many drinks he'd had before or after or even who asked who; know nothing of what he was thinking when he let go of her hand, or if it was the kind of dance that asked that hands be held. I would like to know the songs that played. I would like to know how they knew when it had been enough, that thank you, really, thank you but it was time to go. I would like to know the faces of the people who passed into the space they left on the wooden floor and whether or not those people shared a bed.

How many drinks would there be, usually, between Jack speaking and going silent? Between his impulse to piss on a potted plant and his impulse to piss in a bare corner, between his impulse to throw a brick through every visible window of the building he was stumbling past and his impulse to punch a friend in the face? Between his window of being almost jovial, almost forgiving, and his fury; between his fury and his absolute desperation, between his desperation and his blackouts? These things have a result and perhaps they have a measure. It is astonishing to think of the hours encompassed by this blackness. As if their husks could form a single heap. A

number of days, a number of weeks. I would like to know these moments beyond the expected slurs and fights and being sick in the alley, to know what they mean as they are rubbed away, as they never register at all. From a certain angle, his experience must have felt entirely cavernous. At times it must have seemed almost identical with the column of air running like a cord through the body, marking it with life. This torrent filled with worthless, half-crazed grandiosities and self-reproach, which must sometimes have approached serenity, if we imagine serenity as a kind of resignation.

Watermark

A strange calm covers the town I come back to and I
am out of sync with it, seeking each day another view of
the river, wanting to see how it has arranged itself, what
it has done, how it splays at a different angle with every
cross street. I am frequently sleepless and intent on ove-
ridentifying as a townie who has betrayed some kind of
an obligation, though I say nothing of this to others as I
envy their exhaustion. The bars close and I walk down-
hill toward the water. Beside the student union there is a
fountain wrapped in padded plastic; the mud that wound

around it has dried into whorls, like frosting. Jack found himself a little hilltop and stood on it for a view of the floodwaters after the Merrimack washed away his father's printshop in 1936 and later says he had an epiphany of sorts. Something about the world eating or cleaning itself, destroying its own evil. I would look it up, but prefer instead my own stupidity and insights, which amount to rephrasing this sense of being lodged in the town of my birth, unable to finish a manuscript. *The universe repeats itself without end, and stays in place, pawing the ground,* or so it got copied down. His father was never self-employed again. It's said that monotony must be nourished by the new; thus the highway exhales boredom and light, like the thinnest antechamber or waiting room. Like a thing that cannot stop sharpening itself.

Had I chosen, the ash and ember and their mark would have fallen into the middle of the sequence another patron had placed a line beside, in pencil: *Usually there are dreams of the unexpected secret extra room down a hallway which extends the house into the world, this room happens to be red white and blue, I wonder what are some new things to drink, breathing love, do I deprive you of anything*

Choreography can be broadly defined as the arrangement of steps in all directions.

Idle as a toad, wrote Rimbaud, *I have lived everywhere.*

•

We would like most to be drizzled aluminum, to be useful and blind like a flashbulb. Expertly kept from ourselves and arriving into shining tatters by an anonymous fawning. When you're telling that joke, don't make it sound like a script. Spontaneity is the wish for perpetual departure. The rhythm of its dream is *one and one and one and one*.

Spontaneity, which Nietzsche called a perfect forgetting.

1842. Dickens made his way to Lowell after arriving in Boston Harbor on his first trip to America, where he fumed about his celebrity: *I can do nothing that I want to do, go nowhere I want to go, and see nothing that I want to see*. In Lowell he wanted to see the factory girls, who were well-dressed *with serviceable bonnets, good warm cloaks and shawls*, and their periodical, the *Lowell Offering*. Written and edited exclusively by workers, he thought it compared *advantageously with a great many English Annuals*.

2011. When details are released outlining the planned transformation of a four-acre park at the base of Capitol Hill that will soon be renamed Eisenhower Square, there is very little talk about the two images in bas-relief. These will be etched into blocks of limestone and placed at forty-five-degree angles to a long wall inscribed with excerpts from speeches. The first of these shows *the General* addressing

the 101st Airborne Division before D-Day. In the second he is *the Elder Statesman,* posed beside a globe at his retirement home in Gettysburg. Between these images is a block that stands at half the height of each relief. A single sculpted child will be seated on its ledge. There are numerous reactions to the stainless steel tapestries that seem, whenever Frank Gehry speaks of them, to be the most exciting component of the memorial for its lead designer. But it is the figure of the child that gets mentioned early and often in the commentaries and postings and editorials, and generally this figure is ridiculed. And while Gehry's name is most often attached to this plan, it was not the suggestion of his mind but that of his collaborator Robert Wilson that placed this sculpture at the center of the park, where it waits, in theory, receiving derision. The tapestries hold photo-derived images of rolling Kansas plains and are supported by eighty-foot stone pillars. One commentator calls these *the biggest, baddest bollards around.* The boy literalizes Ike's self-description from the homecoming address he gave in Abilene at a parade celebrating the war's end. *Because no man is really a man who has lost out of himself all of the boy, I want to speak first of the dreams of a barefoot boy.* Later press releases will emphasize that this figure, whose sculptor has yet to be selected, will be wearing shoes.

After the waters recede and the summer grows old we will find ourselves having a protracted debate about this large

and indisputably valuable painting that we came to own for reasons partially obvious but largely obscure or contested along with the question of who belongs to such a *we* and what it might mean to own or remain so beholden to such a thing. It is possible that we became a kind of cult. Protecting and venerating what we could not see, but felt entrusted to. Strands of our argument emerge and percolate through council meetings and local newspaper articles and then eventually guest columns and subsequent letters to the editor and simultaneous online forums; overheard conversations, which were innumerable and which our town and those proximate to it found they were suddenly compelled to have and then to continue having since, as was repeatedly pointed out, the object under discussion has been and is the possession of not only a university, but the state; though what this should or must or cannot mean is also largely obscure and therefore contestable according to a particular purpose or desired outcome that remains, as it were, an open question. The prohibitive cost of insuring anything of value that might now be put into our town's ruined museum remains an agreed-upon fact. The space that was and possibly still is a museum will eventually be estimated by FEMA authorities not to have been damaged thoroughly enough to warrant the funding of its demolition. Thus, because more than half of its estimated value was not lost in the flood, the museum was now a space that had failed to even be properly ruined, unable to be rounded down to nothing. And because *Mural* escaped

entirely unharmed, it is both another kind of problem and an occasion for terse excitement, one that begins and usually ends with the question of its proximate worth, which is estimated to be at least one hundred and forty million dollars. This figure remains inextricable from its status as news. We must continuously remind ourselves what we are talking about. The figure is reattached each time *the Pollock* is mentioned, in part because it was another of his efforts *No. 5, 1948*, that received what was then the single largest bid ever recorded for an auctioned-off painting: one hundred and fifty-six million eight hundred thousand dollars or so, adjusted for inflation. Given time, we will come to speculate that *Mural* is very likely to get at least this much and perhaps more, and so periodically the number cited will rise to one hundred and fifty million dollars, and also, sometimes, to one hundred and seventy-five million, though we will often simply say *millions and millions of dollars* or, occasionally, *a ton of fucking money*. We maintain a serious tone, almost always, no matter how ridiculous we think the situation is. We arrived into the fall that Lehman failed and the painting was delivered to its temporary home at the Figge Art Museum in the Quad Cities. The basic question gets restated, with variations: How can we possibly justify keeping this? How is it not an indulgence to do so? How can we really be sitting on such an obvious asset when our town and campus have been devastated and every penny we can find or create would help us to clean and rebuild them? And, given that, should it be

sold to another museum or a private collector, or should it be auctioned off? And who should decide and how? And if we have to keep it, where in the hell are we supposed to put it and who is going to go there to see it, and who ever even went to the museum in the first place, and what does that mean, and who really thinks so and why? We had not expected to find ourselves in a position to debate the art of monopoly rent. We were dismissed and attacked, in turn. It is possible that we sought to be inoculated. Versions of our story circulate and make acquaintances. Questions about this object or problem in Iowa and what it might mean or imply become, briefly, of interest for a surprisingly large number of people we cannot see; a point at the periphery of whatever worldly attention can be defined by the moment in which a smattering of art blogs and the *Wall Street Journal* find themselves considering the same thing.

2012. *The Sea Is My Brother* gets published in hardback. The book of maritime adventure Jack wrote in advance of ever having any, it is mostly panned or treated as a curio. Reviewers repeat the words *puerile* and *raw*. Jack himself considered the book *a crock as literature*. We became accustomed to the Artist who is most sincere in being openly, blatantly cynical sometime between Warhol and Hirst. We have been described as a line, a terminus, and a sphere. Our time has been defined, we once read, by subtracting the ground of belief from unending confession. We

hock our wares, we vow and placate. The crock, as a form, remains the hallmark trope our moment rolls in.

2008. I'd been taking more of an interest in the impasto shapes that swirl in and out of *Mural* and I wrote about them, or tried, the last time I stood in front of the painting. *Figure: Town. Ground: Scrounging. Figure: Nearly asleep in facing leather armchair. Ground: A far wall made of glass and a view of the water. One riverboat casino on a sunless gray day.* I wanted a gesture that would create the conditions in which a final physical description of the painting's surface could be interpolated. To thread a single thin passage from one corner to its opposite, contriving to replace everything that appeared along the way with the first phrase it resembled. Or simply jamming a stack of these accounts onto a single spindle and writing around the hole it made. *The lower limit of the canvas is almost all hard edges,* I'd noted down the previous week, *a dark ligature of black and gunmetal as if he was nervous that things would seem too much to float.*

Beside the highway there is another. Two exits west of our ruined museum, in the University of Iowa's Oakdale Research Corridor, a nondescript single-story building houses what has been called *the world's most advanced ground vehicle simulator,* exceptional because it not only simulates an experience of motion, but enacts it. An outline of the interplay between its parts is offered aloud over the course

of a free tour. There is the constricted but real mobility of a twenty-four-foot metal dome atop two belt-driven beams that form the axis it travels on and the hydraulic hexapod and yaw ring that connect the two. The exceptional motion envelope they make. There is the three-hundred-and-sixty-degree photorealistic visual environment continuous with its interior wall, sustained by eight Liquid Crystal Display projectors within the dome and their ability to update scenery sixty times in one second. And the interchangeable vehicle shells that a subject sits within, creating inputs. And no, you do not get to just hop into it in the middle of a tour, though you are more than welcome to sign up as a volunteer. For the time being you are free to watch its rounded exterior through an observation window as it lists and swivels and drifts across the sliding rails, the assembly of motion cues now inducing a sense of sustained acceleration, a slight incline, a lateral shift or an almost imperceptible trembling to mark a change in road surfaces as one glides across them, each to the next. I ask my guide if they have done any studies at this site on the time-gap experience and am told that they have not, though recent studies have included measurements of driving performance after ingesting predetermined doses of an unspecified sleep aide.

It's been hypothesized that stampedes gave rise to our earliest acts of hunting. That before anything had ever been sharpened and thrown or shoved into the side of

a passing animal you would simply have approached a herd that was wandering in some proximity to the edge of a cliff. A sound might incite them, or a stone, or your frantic, waving arms. You might succeed and be trampled or they might break in the wrong direction, or it is possible that animal after animal will run toward the precipice as you had hoped, that they would have fallen, snorting and kicking into the rocks below, where they exploded.

Everyone knows that a scroll or printed page or stretched canvas or paint chip is one glint within a time of saturation we call, in vain, a *media landscape*, though how or when all landscape became a kind of mediation or deferral we cannot say.

I want to rhyme three things for you, she said, in a stupid dream I wrote down and forgot about. The scene in his biopic, when they're in bed together and he's staring at the ceiling and she asks *if you could be anybody*.

And the light that's there in the room, the sort of terrible way his mouth is a little bit open and his head moves not at all.

I remember the view from the fire escape outside the small auditorium in Boston where we could see the city trying to widen I-93. We were trying to stay together. We were waiting in line to see William Pope.L. The newspaper told sto-

ries about glacial debris and the remains of crushed ship-
wrecks, the compressed foundations of houses that had
been uncovered as they continued to dig. Ten years behind
them, with five still to come.

We were in the last of five, A. and I. We'd come to see a
performance. We shuffled inside and he got up there and
spent ten minutes trying to take off his jacket. There was
almost no expression on his face. He spoke and then went
silent. The last thing I remember him saying was that all
travel entails the disappointment of arriving somewhere.

I count one hundred and thirty-four staples holding the
right edge of the canvas to the stretcher, one hundred and
forty-two along the left.

2011. *The necessary, agreed-upon quality is modesty.* This was
the only note I starred after watching the hour-long pub-
lic forum on the Eisenhower Memorial conducted at the
National Archives in D.C., which consisted of Gehry and
Wilson speaking at length about vision and process and
presenting some relevant slides. The onstage moderator
says there will be time to take questions. They seem con-
fident and relatively cheerful as they speak, though Gehry
sounds more unsettled when he reaches for a reassur-
ing tone toward the end: *It's going to be very subtle, when
it's all done. It's going to say "Abilene" but it's not going to hit
you over the head with it. And then, finally, the memorial itself*

can be very modest, like him. Earlier, speaking of the statue, Wilson describes his desire for a single point that could stand in relation to the span of a life: *The beautiful thing that kept coming back was that this man—who was a general and an important man in the history of war and peace, a president—that throughout his life you can see the little boy in him. And that's so touching. Baudelaire said that genius is childhood recovered at will. And this is in Eisenhower. It comes in various things that he says throughout his life.* At this point Gehry paraphrases the homecoming speech in Abilene: *He came back and said it's amazing that a barefoot boy could have this incredible life, but he wasn't beating his chest and saying hey, look at me. He was, like, going back to his childhood and saying man, what an incredible experience I've had, but all through it I came back here, because this is where I'm from.*

Dickens, who was driven by stagecoach across the corduroy roads of Ohio. These were made by dumping felled trees into marshes and leaving them to settle. Contractors were required to level only trees that measured a foot in diameter or less. The rest were left as they had been cut. Some stood at a few inches. Some a foot and a half.

The Art of Selling

Writing online for *Portfolio* before Condé Nast will sell it off in the following year, Felix Salmon says that it is a shame that *Mural* is not the greatest painting of the twentieth century, though it is possible to understand why and to correct the situation. His own touchstone is a list compiled by a David Galenson, a University of Chicago economist who published a paper six years before the flood entitled "Was Jackson Pollock the Greatest Modern American Painter? A Quantitative Investigation" which I would read, if I were a subscriber or corporate associate of the

National Bureau of Economic Research, a journalist, an employee of the U.S. federal government, or a resident of nearly any developing country or transition economy, for free. I crib a description of his method from the paper of record and find that his list was determined by tallying the number of times a work or artist is mentioned or illustrated in a given set of textbooks.

Salmon points out that *Mural* is not even on this list, while Picasso's *Les Desmoiselles d'Avignon* stands atop it, and that this discrepancy may or may not really make much sense since they are, he explains, so similar—both painted by *young artists who were about to break into the big time . . . large, raw, ambitious, stunning works which revealed a vision capable of changing the course of art history. And while both lack the elegance and beauty of some of the painter's later pieces, they more than make up for that in their sheer insistent power and determination to be heard.* There's that word again: *raw.* A small thing. The one who makes the raw work may not know or even care if it is any good at all. He may sell it for a song. If you understand anything about language at all you will probably understand that this shout the painting makes is metaphorical and available to ignore. If you know anything about the current art market, you will likely realize that *one of the reasons that contemporary art goes for such huge sums at auction is that nearly all the major art of the past is now in museums and therefore can't be bought for any sum. But there's a corollary to that well-known fact, which is that some of the greatest paintings of all time have*

216

washed up in relative backwaters which don't and can't do them justice. This is where we come in. Since you also probably know that *not all museums are equal*, it should not be so difficult for you to concede that if *Mural* had ended up in, for example, *MoMA rather than UIMA, it would probably at this point be generally considered to be the greatest American painting of all time.*

There is something almost interesting about a town that holds a thing in a way that is a shame. That damages it through inattention. And something almost marvelous, perhaps, or ridiculous, in the corollary paradox that is implied by Salmon's argument. Since, hypothetically, a town might even read it and come to readily agree that such a painting deserves an audience in one of our finest cities, in *New York (or Washington, or Chicago, or LA)*—a city where it will be surrounded by informed people who appreciate the privilege of seeing it. We would need to be, not liquidators, exactly, but reasonable people who see what's best for Jack and Art and capital and everyone. Though if a backwater could be reasoned with this way, we would also threaten to become precisely the understanding and appreciative cosmopolitan audience that such a painting deserves. Put another way: if we proved capable of selling this painting, we would have to be the kind of place that should keep it. For such a town, some generosities may prove impossible.

What Is Favor

Descriptions of downpours and floods recur and circle Kerouac as he gets old. They never really improve upon the fifth chapter of his first published book, *The Town and the City*, where the river *swells and elbows darkly through the folded shores, all bulging, all softened by rain.*

1994. In anticipation of the night, Catherine Opie begins to take panoramic photographs of highway overpasses in Los Angeles. Because she wants them to be empty she shoots on weekends, in the early hours of the morning. She aban-

dons plans for towering wall-sized versions of her platinum prints in matte shades of gray, preferring to evoke Du Camp's calotype shots of pyramids by scaling her images down to the size of a hand.

1968. A lecture shows its age or limits by assuming that some opposition to risk still exists. That there are still choices we could make that would not imperil everything.

To begin by saying we sought or needed again, only the simple and impossible questions. What would it mean to make a thing? Or hold to it. To keep saying so nearly nothing, able to ask if perhaps it was not nothing, but everything that was at stake in thinking of or toward love and its failures. Not the failure we were, but the cipher. Not the highway but its pathlessness.

Jack goes slopping through the Village in a near-silent fit; goes trudging through the carbon filth and light of the city, electric and shambling and alone, with no phrases to please him. If he spills, if he leaks and fumes, is gradually made a vapor, if he has stayed much too long at the fair, then it is only there where we will meet him. In the whirling blind autumn of empire where days seem more and more the same, like waves. Alike as sighs. As snakes.

Our museum's former director was said to have had a long-standing, legitimate offer of one hundred and seventy-five

million for *Mural* from a private buyer, which was presented to the relevant boards and authorities and renewed several times. This, along with his persistent attempts to persuade said authorities that our as-yet-unruined museum should be relocated downtown, was thought, in several circles, to have been the primary motivation behind him being asked to resign. He complied with this request. His strategic motives for proposing the move and sale are not so mysterious—the museum would be more integrated with the fabric of our town and in place of *the Pollock* there would be liquid capital that would go directly into growing the permanent collection and beyond. The sheer number of new pieces that could be acquired and the consequent proliferation of choices and opportunities for lending and exchange—all of this would have been a framework rewarding foresight and prowess, in which a director could manifest what is often termed *vision*. I only met him once or twice and have no real idea how he felt about these things, but it is hard to imagine that this possibility and its proximity were not intensely tantalizing, perhaps overwhelming.

There is an *anomalous swatch of bright orange, green in the corner of its flaring* somewhere in my notes. It is there in a cardboard box, among envelopes in piles, *cool blue clay from the creek and the taste of water from an aluminum canteen, the consistency of dry-rotted railings, teeming gnats.*

•

The contention that he could only stay interested in the possibility of completing or abandoning the first painting again. To be such a one and caught as one.

To make, from line, one reticulated script.

That it is craven, that line: *safe in heaven, dead.*

These stumps, Dickens wrote, were a *curious feature in American travelling.* They were *astonishing in their number and reality,* which shifted as they passed and their outlines angled and stretched into bits and pieces of old, haggard situations, temporary emblems piling in upon his sight and *now there is a Grecian urn erected in the centre of a lonely field; now there is a woman weeping at a tomb; now a very commonplace old gentleman in a white waistcoat, with a thumb thrust into each arm-hole of his coat; now a student poring on a book; now a crouching negro; now, a horse, a dog, a cannon, an armed man; a hunch-back throwing off his cloak and stepping forth into the light. They were often as entertaining to me as so many glasses in a magic lantern, and never took their shapes at my bidding, but seemed to force themselves upon me.*

It is not specified whether the figure of the child will be cast or modeled by hand. In the debates that follow there is an odd deference to the threat that he is. As if somehow the silent child that the park is arranged around will force us to betray ourselves.

•

Put otherwise: every present bears within itself an accumulation of past failures. The preferred term is *torpor*.

A life or body of work dedicated to authenticity invites an afterlife mired in fraud. Thus his mother's contested signature on Kerouac's estate papers. Thus a purple thumbprint on a paint can will also play a role in the story or legacy of Pollock's painting. It is time that we figure these things out. A family friend says I need to read this really fascinating piece in a magazine he'll let me borrow, arguing that there is one thing undergirding everything on the canvas of *Mural* and it is only his honest loping name and without thinking I say it seems a little *whoa, dude* to me. Not that I would put it past him. Jack did all sorts of stupid things. Often that's what we depend on him for, while we pursue forensics. Thus a newly discovered canvas whose veracity will be denied or affirmed by our ability to track the fractals in it. Sometimes I think we wanted to see past seeing. To be alive again in a way that felt like knowing. We wanted not a seeing or an understanding of what was passing from those moments between deciding and decision, between hovering and contact, but to be that interval between none and both. To find a line that plays to weakness. Our wish was old and simple: to read the illegible. To be like entrails, stars, and dances.

It spreads constantly swirling, spreads billowing; it stands blooming, rustling, spreading its branches; it has fingers which are spoon-

like, concave, dark; it is not enduring. It spreads, it extends. It falls apart. It is an adhesive, a filler; it extends, spreads, radiates.

You could paint the house party that you found your way to, early in your last year of high school. The moment when you walked into the kitchen and saw them snorting crushed vitamin tablets to trip harder. Or maybe the way you spent almost the entire evening with a single friend, and so much of it talking about Jack and his beautiful soul. Then that he stripped down to his boxers and elbow-dropped a bird-feeder from atop the wooden fence in the side yard. Or how it felt to walk down the alleyway behind the house and see another house, one that you were brought to as an infant, the first you ever slept in and have no memories of; how you watched him climb onto the hood of a Volvo as it was pulling away and begin pounding on it, and how you turned and started back up the alley toward the house. The moment when you asked the police if you could go find your coat and the feeling when they let you. And when you were told two days later that they had put him in the psych ward that weekend, the simple choice not to speak of it again.

The highway as it bathes in insentience. Gesture and its remnant: notching a stick, swiping a credit card, tucking or unlatching, the vague refrains of radio static.

The first phase of a hypnagogic dream can be tracked by lying flat on your back with one arm propped vertically at

the elbow and a recording device beside it so that, as sleep approaches and muscles go slack and your hand falls to the floor, you press the button and begin to speak. Not flakes but stems. The time in it, suspended, a place without features, wherein we cannot meet.

The eye moves across the Peutinger table with nothing to hold on to, no pronouncability or regional color. A jag in the line to mark a day of travel.

2008. I drove you to the airport in the middle of the morning. The deer were crazed with spring and the highways strung with gore. We drove past the scorch-mark on the opposite side of the underpass, then an exit sign for the birthplace of the president, and I moved my hand toward the black feathered traces left from the van's collision. My voice stayed flat and matter-of-fact as I said that he had first tried to asphyxiate all of them in the garage. That he had embezzled just under a million dollars, as the paper had reported. But it was the spring, not the fall, and so this still seemed like a great deal of money for one banker to walk away with. Or it seemed that way to us, in a town like any other.

Or say that Jack's last notebook was made of mulberry pulp. That he kept it beside the telephone. That sometimes ink, as he put it to a page, soaked all the way through.

•

Mountain peaks and the remaining conifers that ring them.

Notley, who waited twenty years and change to write that *if god is ground / god could be in a person, could be like a person / having to mimic our every idiocy.*

2008. That I read or reread the relevant lines before wandering through the park to the edge of the postage stamp prairie, walking the entire perimeter before stepping in. Near its center there were paired tire treads left by search parties, incised and leading out.

You could paint the lowland cities and pottery shards, the boulders and veins of blue jade suddenly available to sight after hurricanes strip the surface scrub away.

In my father's dream we drive around an unnamed town and fail repeatedly to find an apartment to rent on account of my pet monkey. It's raining, then snowing, and I have to climb into the back to change the monkey's diaper. He doesn't say who's driving but we're in my old car and pulled over and he's standing on the sidewalk when his grandmother steps out. She says, *I haven't seen you in so long.*

2008. This was the fall that we spent briefly asking aloud what it was we were seeing, what was possible, what we held within or were capable of and what could possibly be

wrong with our town, in ways that had nothing to do with a painting. A story in which the body is recovered by a search party within shouting distance of his parked car at the lower entrance comes to an end three months after another man made the same decision in his garage. But it was the morning in March I could not stop thinking of. Looking up and down the street that ran across the river, pressing the button on the phone in my hand to end the call. At some point between midnight and four in the morning it began and ended; three in their bedrooms, not the garage, the youngest in the toy room downstairs. By six-thirty he was on the highway driving away from and then toward a town like any other, a town unable to see such decisions as part of our story. We described some kinds of violence as *unimaginable*. Maybe this is not an analogy.

Maybe it is simple: the unseen preserves its power by remaining so. Say that place should be introduced in the opening paragraphs, like character: *the gloomy setting of more trouble and tragedy lately than could fit into a single book*, according to the paper of record.

Or say the god grew weary and the eagle also grew weary. That the liver was ever-widening and could not be devoured. That the figure disappeared into stone.

Preserved or cast. As ground or muteness, time or fact.

•

Where tree spiders rewrap mangrove branches in a thick gray gauze of webbing declared to be *the largest and strongest ever recorded*.

The prompt was *desire* and I said *tickertape*. The prompt was *neighbor* and I said *blast furnace slag*. The prompt was *place* and I said *eat the egg, eat the earth, eat the good, thick lake, the dull dust, eat the rain, the burning snow, eat the last mouth, counting.*

You know where you are by the overpasses. You know where you are.

A place made of Baedekers and local touches; a town with a large park well away from the river that splits it, a park periodically speckled with kids getting stoned and sometimes swimming in the creek. A town where sometimes a boy is duct-taped upside down to a tree and discovered the next morning by a jogger. Some stories are told over and over because we want to stay the same. This is a town like any other. A town made of tunnels and bars and flickering lampposts. Long winters and the same guy playing the same Otis Redding song on the corner downtown each day of every summer for years. Where you will often find others to stay awake into the small hours with, in the attic apartments with views of the powder blue sound of sparrows calling because there will always be others with no real reason to go home.

•

Say that the dappled patterns in the mulberry pulp emerged in cool, mute inconsequence. That every real monument is invisible.

The mountains, the crags, the rocks are its growing places; it stands growing. Its blossom is a little long, hollow, yellow, very yellow, yellowish, like embers, much like embers, a fine-textured yellow. It is of slender stalks. Its blossom is cylindrical, roughened within, very smooth, soft, nerve-like; thin in all parts, stringy, compact, very compact, quite tawny; cord-like, hollow, jointed, pithy within, it breaks the flesh, seizes the flesh. It resembles a hand.

And the wish to find resemblance as nothing but the desire to become something else. And the newness of old things, like snow.

Wilson says that this image just kept sticking in his head. *One of the great things about this country—and it's part of the American myth—we say it's as simple as apple pie. Jackson Pollock painted with housepaint. Abraham Lincoln was born in a log cabin. And so this idea of the barefoot boy from Kansas who, toward the end of his life has this way of reflecting on himself as simply a boy from Kansas somehow became very compelling.* Gehry begins to talk about the site and the particular landscapes that would be woven into the tapestries, which will include sycamore trees with silver bark, also

native to the D.C. area. He scratches the left side of his face, brushing his lapel mic with his sleeve, *We realized this is an incredibly fortuitous image to pick, from a functional standpoint, because it allowed the most open space in the sky so we could make it transparent, so that the guys could look out and it wasn't bombastic, it wasn't overpowering, it wasn't beating-your-chest Eisenhower it was just, bringing in the Midwest, kind of. Abilene is four hundred miles from the geographic center of the United States.* Among D.C.'s existing monuments, he says, *I don't think there's a representation of the Midwest and there's a lot of people out there.*

Please Sign In

What we know about *Mural* is: *Rumor cannot make it local enough.* Also: If it's that expensive it must be important and everyone who's been to a wedding knows it's really rude to sell a gift. I don't know much about art per se, but if it means you clean up the campus for nothing then box it up and ship it, you've got to be kidding me. Call me a philistine, but I just don't see it and if you think we'll get that price in five years you are completely fucking nuts. Art Market = Part of the ECONOMY. We're going down, people! I'd never heard of it until yesterday but my wife

went to school there and took an art history class—didn't talk about it all semester. Just saying. Why does everyone think this needs to get figured out this week anyway? So I'm supposed to explain why they need to keep this thing to somebody who's teaching in a trailer next semester because I'm just glad to see people have stopped spelling his name "Pollack" since really this is really distressing really sell that shit another great example of the university being shortsighted and if this doesn't get the latte-set into a fit, I don't know what will because this is just what happens when you start running institutions of higher learning like a business. This comment field is a disgrace to the state. This is another example of the university being totally out of touch with whoever's not part of their donor pool because this whole thing is a real no-brainer and suddenly everyone talks like this isn't our tax money like you don't even understand that the most basic thing about museum ethics is just that mural is worth so much more than its pricetag and anyway obviously any painting going for that much is overvalued. Would somebody please point out that Pollack had no connection to Iowa anyway and we could use the money to buy work from artists like Grant Wood who actually DO this is like renting out the university's medical equipment to raise funds for a football stadium I mean, what if we took five percent of whatever, the difference is that those facilities pay for themselves and have nothing to do with anything because the difference is like would we really say hey, let's sell some MRI

machines because there was a flood? No. So now everybody's an expert on everything that's way too valuable to lose and you say that you take your kids there to see it but anyone can say that anyone can see it's basically a mess it's basically the crown jewel of our internationally renowned are you even serious I mean has anyone even pointed out that this would work out to be a 100% profit? That this is another example of the university being really shortsighted and obviously you need to calm down anybody could have looked that up on wikipedia so that doesn't prove anything point taken but everyone knows that this is just a ploy to get more attention on flood damage to the arts campus and funding for they'll never sell that painting. Just because you say it's something to be proud of doesn't mean I can't say that anyone who compares that painting with medical equipment is insane. I mean it. I'm amazed to be reading this. People are always going to say they know better, but any adult who understood money wouldn't think twice about this one.

What Is Enrichment

I awoke in your living room to watch birds through
the window half the morning, frantic with the first snow,
and the fingers of powder falling from the cedar tree as
the wind picks up, and the paths they traced overlaid on a
single panel of the window. Walked out through the yard,
past a few upright outlines of spur grass and then the sud-
den smear of fragrant ash beneath your step as it pressed
uphill into what was left from yesterday's prairie burn and
the brittle give that the ash has, and the strange freshness
in the scorched smell emerging like black speckling that
trails your boot print.

•

I wait to see what comes next. I click the button to renew the page. I am attached to this scene that is pursuing an obscure and intimate delirium. Perplexed, but still intrigued by the way the conversation we were having or pretending to have about this painting could not get started or end. The way it seemed to turn and wend in every direction in order to go nowhere, at least in part as a way to show the medium of exchange that *Mural* was, or had become. Absorbing in equal measure what was nonsensical and germane. And it gained this strange immanence, which focused so intently into the question or proposition of its equivalents; and this became the indisputable gall of the thing, which demanded and received so many claims from so many of us suddenly asking after it. And there seemed, at particular moments and sometimes for days, to be equivalent questions afloat about what was and was not replaceable and what might return in its stead, if we let it. Or what irreplaceability amounted to. Or how transformation and exchange and opinion and motivation and expertise could be properly understood. And beside this uncertainty came a demand. That *Mural* must announce itself to be only a kind of potential, or only a legacy. It seemed we could not help getting carried away. This was not a painting, but a way to speak about endowments or entitlements or ridiculous administrative costs or how much a coach was or should be getting paid, or affordable housing for everyone, now, or the revival and continued relevance of

wetlands or a check in the mail for every tax-paying resident or foreign aid to Zimbabwe. And I wanted this too. Wanted to see how long we could go on, how much further afield we might get, as we entertained the question of the huge and stupid and unprovable painting. Wanted to be interested in the way we had found ourselves suddenly unable to find a floor that could establish any premise or tacit agreement about value. And how this only necessitated that we make further claims.

And it may be that fluid, left to itself, will seek or find an untroubled line when falling. So that expression is only his getting-in-the-way.

To be a steward. To be graft. To be loud, canned musicianship. To be alone in a field. To be the break or interface between having and pretending.

Or that's what he didn't understand, our former director. That we didn't see ourselves anywhere in that trade, didn't imagine ourselves as cagey, wheeling and dealing—but as placeholders guarding a legacy, a heritage. Did not share, exactly, our sense of treasure.

To withhold the map. To have hungered. To temper and flag and crab. To outlast each demand. To finally press the dawn into your rotting bonnet. To be given chances. To make a mess of it.

•

Dear Untimeliness,

You are going to be fine. Pick up that feather from the tabletop. Now try to set it down. Everyone respects you. Accept that just in front of you there is a single line of ball bearings. They are contiguous, shining. Do not touch them. Wait until they start to slide. You are going to be fine. Specify the color. You cannot leave until we check you out. We know the kind of promises you make. We agreed that speaking of it only keeps us both distracted. Your doubt is not a god or his death; is not a child or a disavowal; not a candle left alight or a woman the scene is described to. Your feather will not disappear if a sound or a candle is added or left out, if the color specified is pale gray or lead. It will not ask what arranges excess and omission. It will not ask if your hand is inconsequent. Try to fear your feather. Let it go cold and slack. Not your fear, but your attention. Keep your fear like your errand: coiled, lithe, and shining. A lot of convoluted fuss gets made about the name of the feather, but never as much as it feels entitled to. You are going to be fine. This is only an exercise. Forget about your lucky penny. Forget about your faux Rimbaud. No more it's all-right, ma. No Peggy, no lapdogs, no thimble, no thumbs. Nothing is impossible and nothing is destroyed. Say aloud again that it does not matter if they came and took him away from the party or the hotel or the public square. If he went by your name or mine. Or who he went home to and said he was unafraid to sodomize. Say that home was

an owner and god was a number. A number doesn't mat-
ter. We burn up a house and its contents, we change the
form but the same elements exist; gas, vapor, ashes. It is
Jack that is our singer and a name that spends his versa-
tility. Since implements and machines cannot do without
him. Since he pilfers and confounds and becomes a com-
mon sailor, alone as Jack Tarr. He is compounded by lan-
terns and boxes, is fond of homonyms and pastries, Jack-
a-dandy. Such a one, such a man, such a modern modern
man. One among the French peasants, threatening to grow
dull if work and play have their way with him, if work
and play wear him through into one, into such a one, such
a modern as thine eyes will never see again.

A man who looks like Trotsky has a question: *Mr. Gehry,*
previously you've been quite forthright publicly about your design
philosophy, if I may quote something you previously said: "Life
is chaotic, dangerous, and surprising. Buildings should reflect
that." He reads a second quote in which Gehry used the
phrase *controlled chaos*, then asks him: *Given your stated pre-*
dilection for chaos and danger in architecture, is this project a
continuation of that, or is it a departure? And moreover, did you
explain your design philosophy when applying for the commis-
sion? Gehry, whose work depends on software meant for
the design of fighter jets, pauses.

He says he was probably talking to a bunch of students
who were afraid. He says he has a nose-hair and if you get

in close you can see it. He says that the chaos of the world is a fact and lately it's come to be more of a fact. He talks about the formats of the past, of six- and seven-story buildings lining the streets of Europe. He seems a little thrown, but mostly embarrassed on behalf of his interrogator. He asks him, *Do you think this is chaotic?* The man says, *I happen to think that the giant screen represents winter, permanent winter—trees without leaves—and it represents death and nihilism in the same way that I see your black T-shirt, much beloved by downtown hipsters and nihilists everywhere and its total rejection of the past and tradition and, honestly, everything that Eisenhower himself stood for.* Gehry pauses again, then leads the audience in applauding.

With the Hogs in the Tanyard

The profession listed for Leroy Pollock, on the birth certificate of his final son, was *stonemason*. At the age of sixteen Jack will accompany him to the Grand Canyon for the summer, where they will work around its edge laying a two-lane road. According to his oldest son, it was the work as a road-surveyor that broke Leroy. Jack generally refused to speak of his father. When reading about his son, we often hear Leroy described as a tired and hopeless man. He had been adopted at the age of three, after the death of his mother and older sister in quick succession.

His biological father had felt unable to raise the child and so put him in the custody of a neighboring family. Not adopted exactly, but taken in, clothed and fed, then put to work as a farmhand as soon as he was able. Mostly Leroy hated the Pollocks, his adoptive family. He tried to run away multiple times, once making it all the way to New Orleans, floating with a friend on a handmade rowboat down the Mississippi. Leroy had read and loved *The Adventures of Huckleberry Finn*. Maybe it was what he thought about while the two of them worked in the kitchen of a cheap hotel for a summer's worth of room and board before his whereabouts were somehow discovered. They were sent two train tickets back to the farm in Tingley, Iowa. They decided to take them. Imagine those moments, the feeling of accepting that ride. Or say you cannot. Or that you refuse to. I do not know how many people were on the road crew with Leroy and Jack. Some biographies say it was the first summer that he really got drunk. Did Leroy tell him, during those months, or ever, about the day he went back to Tingley, as a man and a father, in pursuit of the first name he'd been given, which was McClure? He sought to change it, but the legal fees were more than he could pay.

Neither Moth nor Rust

2011. Because the museum has successfully resisted selling *Mural*, the demand that it must do so can be endlessly renewed. This is the year that a panel within the statehouse approves the sale, with the expectation that an amendment will set the minimum price on the painting at one hundred and twenty million dollars. And even if it sometimes seems to make so little difference where a painting goes, the possibility of the Guggenheim Foundation pursuing a lawsuit in the event of a sale seems eventually to save *Mural*, if such a word is appropriate. Since the

recursion of economic crises will remain inextricable from our chosen mode of living, we can expect to return to these conversations. Perhaps someone will finally answer the question posed by the museum's newly appointed director on the day the subcommittee reached its decision: *Is nothing sacred?*

Began *I fail to be persuaded every time you bring it up.* Began *I cannot see the trees or the light coming through, though I sense it generally like the sound of your breathing, quick and sharp as we turn up the ramp, then left across the overpass.* And struck out *line, encasing light;* struck out *seeps and hedges, peels.* Struck out *left, across the overpass, then down the ramp and back into the highway's opposite direction where he drove and drove a little longer toward the next overpass and its pillar and flames and the color there left after.*

Gesture, like infrastructure, appears as inheritance and therefore mystery. I do not know why I move this way when I talk to you. I am a test set, a schism. I am an interface between earth and air. I do not know if I am leaning toward you or receding when I tap my fingertip and thumb just in front of my chest. I cannot see what shapes me and cannot accept what I am beholden to. This is one definition of being a person. I would not call it thinking. You were holding court in the living room with your oxygen tank. Or home from the war, asking for a raise. You were alone at the kitchen table, emptying a glass.

•

Because the highway cries all night it can remain a fixture in our cinematic dreams of apocalypse that promise to make any and all of our remaining choices weightless. We try to believe this—or, more specifically, in the persistence of concrete—at the expense of noticing that it gets replaced every third year. The absence of vehicles will not preserve it. It is only water that will be required to quickly rip it apart.

Gehry says, *It's a great image of hope for kids coming there, too.* *Yes*, Wilson says, *it's the American dream. And it will be life-sized*, Gehry says.

Not water but time's alliance with water as it flutters back and forth between liquid and solidity, infinitely more tireless than limestone spread and set into a suspended strip or cloverleaf. The highway is an overestimation. A distension. Water is the simplest chisel. It oozes and swells through the smallest punctured tunnels where continuity and fracture meet and rescind.

And maybe those first evenings around a campfire near the canyon, sharing a bottle in the company of men, had a warmth to them. Maybe he was trying to remember that each time he sat at the Cedar Tavern. Maybe it was not warmth but honesty he thought he had heard or touched. So that his idea of friendship could be or remain the

question of how unremittingly hateful can I be to your face and still be loved and accepted and slapped on the back? These were the ways he had of seeming clear to me.

Dear Candor,

The longest trip we ever took alone together went somewhere near these scenes. The shapes of rock like car keys outlined against the early blue night. I'd been reading everything by Ginsberg and you asked me why and not if I was queer. I said what I said and you talked, as we drove, about theories of frontiers, then Thoreau, then the death of the family farm. You were the kind of man I was afraid of and wanted to be. I cannot tell if writing that's a lie. I could not and cannot remember the only serious car accident I was ever in. You always began by saying it had been very late and neither of you wanted to get a hotel room and I was only asleep in her lap because I refused to stop squirming in the backseat; you always ended by describing the shape of the patterned crack my head left across the surface of the windshield.

The first and only time I saw a play directed by Robert Wilson I wanted to stand and applaud at the end, but no one else did, so I stayed in my seat. Afterwards he got on stage and took questions, and I tried to ask how he understood the concept of conversation, since his staging was clearly thinking about or in some correspondence with Prospero and Caliban and Beckett and that psychotic faux-fifties element

in David Lynch and yet the characters on stage never spoke to one another. Maybe I wanted to hear him declare that there were exactly five kinds of dialogue but he only used three, or to say what it felt like when things spoke across or through him. It is possible that I sounded fairly manic. He responded by describing his long-standing weariness with what he called *ping-pong dialogue*, and as I listened I felt convinced that this was not a paraphrase but a word-for-word replication of an explanation he had given at a question-and-answer session I had attended after a show of his digital portraits at the museum two years previously, down to the number of times he mimicked the sound of the ball hitting the table, then the paddle, then being returned again *poch-pock, poch-pock*, and it seemed right to feel diminished. Not because I had entirely failed to engage him but because his set-piece was convincing each time and did not need to be amended. He made you feel that you had lived through these moments a thousand times and were so tired of them that you were ready to follow him anywhere he wanted to go. Mostly I wanted to concede to genius. Mostly I was afraid of art. Or the way that it would absorb everything you could ever think to offer, propose or throw at it and make these things into refrains or themes, hobbyhorses or blue poles or poorly timed tics and you never got them back.

A scroll may seek mere irreversibility. The soul may appear only in clinging and decay.

•

The most beautiful and terrible things cannot be written, cannot be said. That's where you come in.

Sometimes, she said, he would crawl up the stairs. Too drunk and weak and sweet to do anything else.

2012. In late July it will be remeasured and bubble-wrapped and strapped into place within a long, tall wooden box, packed and shipped from Des Moines to Los Angeles, where the Getty Conservation Center has offered to fix it up for nothing. The collaboration is a distinct triumph for the museum and will be followed by a brief global tour for the painting, with destinations as-yet-undetermined. Maybe Venice. Maybe Rome. It has been suggested that one or several BRIC countries should be included, since such exchanges might be parleyed into greater exports of our state's grain and pork. The restoration of *Mural* will begin by addressing the pronounced sagging that can be seen near the center of the painting, toward the top. There will also be a focused, strategic reinforcement of the canvas's stretcher. The sagging is thought to have been caused, in part, by a procedure called relining, popular during the seventies. A coat of varnish was applied to the back of the canvas and is now seeping through. The colors have changed a little. We are relieved by this return to practical problem-solving, eager to see distortions removed. If they can manage to get the relining out of the canvas it won't be a drastic transformation, explains Yvonne Szafran, the

head conservator of paintings at the Getty: *it's not that the varnish has yellowed dramatically, but it's like a veil sitting on the surface of the painting.*

Wilson suggests that Gehry talk about the figure. Gehry says that Wilson should talk about it. Wilson describes the tapestries as a kind of scrim.

It lies scattered in small clumps. It is a little white. It is coveted. It is reducible to many parts. It has spines, it has stems, it has a silk. It glistens; it spreads. Its butterfly-shaped leaves are herb-green. Its blossoms are white, yellow, chili-red, pale, striped. Its center is not large. It falls easily to pieces. I cut, spread them out, arrange them, cover them with leaves, it is raining, scattering, showering down, it is tender, very tender, flexible, infirm. It is one which sends out runners. It is a precious thing, it is one which can be claimed as what one merits. I claim it as merited. I appropriate it. I take it to myself. Its bulb is well joined together; many are its coverings. They are cylindrical at the base, whorl-shaped at the top. Its tendrils are soft, tender, searching, delicate like greens.

On Exactitude

A mode or tactic of preservation can acquire its own momentum and hue. It can require a certain focus. *Focus* might be defined as the elimination of every question that is not asking, *How can we continue doing what we're doing, keep living as we've lived?*

Say that *the Pollock* holds out the promise of doing right by another, for the sake of ourselves. That Jack is this *becoming-swag*: displaying the digits of his retirement account down the sleeve of his flannel shirt as his arm works the

unseen canvas on the floor of the brick-walled studio he tromps around and ages gracefully within. Or he is played gamely as a can't-quite-fit-in kind of girl, straight plain hair in a ponytail, wearing glasses and overalls so that no one in the rapidly aging spoof of the teen comedy genre will be capable of noticing her beauty. We watch her in art class, alive inside the overblown corndog mania of an inspiration as it is spliced together—giggling with a hand over her mouth, then snarling, then weeping and flinging something, and she is so blatantly, tamely beautiful holding two brushes out in front of her and flailing them forward to pummel the canvas she cannot see because her eyes are closed, her head tilted away. Easily the most bombastic display of acting in the movie itself, its mockery of painting indistinguishable from its mockery of theatrical exercise. As if to say who *doesn't* get the joke of Jack and AbEx? Who doesn't see the underside of absurdity as mere terror? Since it is not just bodily fluids we imagine into these works or lacy, refulgent clouds, or patches of odd mottling among shadows, or the churn of oceans, but the instant or aftermath of nuclear attack. Since what, but Art, and who, but Jack, would ever make the bomb mean something past that limitless negation of meaning that it is? And at his most majestic Jack pulls each of these into the other, fusing landscape into annihilation, melding the door into the barrier. And in that, he was like capital. Its twaddle, its flood. Even if all he wanted was a way to stave off the choice between loving and hating paint: to make a

compounding, an admix, an alloy, a blend; a faultless space of no decisions and all decisions; of sketching or none.

2012. Within the walls of the Getty, where thirty-four paid positions, mostly in education, were recently eliminated, there are several ambitious techniques for understanding the alterations of paint in response to age, environmental conditions, and conservation treatments. The spectra of acrylics, polyvinyl acetate, and alkyds are readily detected with pyrolysis gas. Ten positions were specified in the cut, with the remaining twenty-four to be determined. Liquid chromatography—mass spectrometry allows compounds to be separated into columns for research and analysis; it is a *promising technique for identifying different types of additives in acrylic emulsion paint from a single sample.* There is a dynamic internal to the time of fascination. A torsion of sense, in which we are simultaneously seeking an extreme proximity to something and experiencing this proximity as a barrier.

2010. We remain alive and available to education or its semblance in the ongoing aftermath of risk's migration into finance. We've come to understand that it has gone there in order to redefine the vanguard of abstraction. Also, that saying a word like *vanguard* or *there* is to play at being naïve. We notice that not one but two murals will adorn one local space of flows; commissioned and completed by Franz Ackermann and Julie Mehretu during succes-

sive years of crisis for the entryways to lobbies of 200 West Street in lower Manhattan for a firm whose name appears nowhere on the building's exterior, nor in its lobby, nor on the uniforms of the security guards who watch over the work on behalf of Goldman Sachs.

And so the museum that could not be used and could not be destroyed retains a kind of charge. I go there to stare at the sealed windows, to arrange petty things I can remember. The little golf pencil they gave me at the front desk across from the coat room with its modest footlockers and keys tied to laminated chits. This is one way our greed displays itself to us: despair about pleasure. Because it is an impasse, the museum reminds us of the present. The museum that could not be used or destroyed and the darkness in its windows and the night sky reflected and the thickness of the darkness reflected in its windows and the satellites provided and providing for the impasse of the present and the old sound of new things like *motion* and *stillness* repeating that everything alive aspires to the museum or resigns itself and dies. These choices, times, or gestures repeating themselves endlessly in some never-attained awakening. This cannot account for the horde we fear and hope for, cannot account for its unknowable approach or swerve. The sky at night reflected and the truth that Ike, not Jack, encompassed for the present when observing that *things are more like they are now then they ever were before*. Which remains indisputable and asinine, like

our moment and its satellites. The conversation we were meant for never arrived.

Though if chaos is not just disorder but an infinitely accelerating, colorless sheen, if it is the threat of thought ceaselessly escaping itself, of forms taking shape and disappearing in an instant, then it will obviously be as antithetical to architecture as modesty is to the monumental. Wilson does not mention that his own teenage years coincided almost exactly with the Eisenhower administration, or how this man seemed to him then. No one asks him if he thinks any country or time has ever been as persistent in finding vague new ways to doggedly pursue Baudelaire's definition of genius. Or what the risks might be in depicting fantasy so directly. To be at once in anticipation of and encompassed by the bewildering reality of one's power; to believe again in modesty in a country so nearly dead to itself. Determined to believe it could be deserving and wise, so nearly omniscient, and innocent. We cannot say what a monument is. We cannot say what came from being children.

I hear it shifting and hissing from my seat beneath the stilted porch. It is very early in the morning and I'm the only one up. The highway and all its anywhere. Or only the thin gray rinse of it, mixed up with the wind in the trees, scrub and clutter.

Jack, like any phantom, returns ceaselessly to his origin.

A veil or haze, an exudation, a resin. Woven through slow diffusion, luminous or sallow. Its intimacy like an envelope. It accrues. It is what our staring wants to be.

2012. In October a preliminary review of the memorial is announced, then postponed. In lieu of announcing when they will reconvene, the National Capital Planning Commission posts a two-hundred-and-fifty-six-page design booklet to their website. The report, submitted by the National Park Service on behalf of the Eisenhower Memorial Commission, outlines preliminary site and building plans, including overhead studies of thirty-seven versions of the design that have been generated thus far. While *not all-encompassing*, these have been included *to represent the evolution of the Memorial designs at key submission dates*.

The latest revision of the memorial shifts the images of Eisenhower addressing troops and Eisenhower retired with his hand on a globe from bas-relief into full-scale sculptures. The seated boy is replaced by a young man. He stands upright, just under six feet, wearing a cap.

1918. The first record of a sandpainting's preservation occurs several months before the transcontinental convoy assembles to head west. In coming decades practitioners will often compromise by including deliberate errors in paintings that will eventually be displayed in living rooms,

department stores, or hotel lobbies. This option may or may not have occurred to officials at the Arizona State Museum as they sought to convince Sam Chief (Yellow Singer) that he would be remembered as the man who saved the Navajo religion. It is not clear that he agreed with them or what eventually persuaded him to concede. He thought he would go blind.

Then

1956. In a year the book will be bound, published as a modest stack. On June twenty-ninth, the National Highway Act is passed. Ike is all smiles all day. On August eleventh, after a few years of almost no painting at all, Jackson crashes his Oldsmobile into two small elms, a quarter-mile from his house on Fireplace Road.

August 22, 1986. They couldn't get the governor. They couldn't get the Secretary of Transportation or even the head of the Federal Highway Administration. *Attendance*

was not politically expedient. The lieutenant governor shows up and local administrators make do. They have some speeches, some ribbons and champagne. The last section of Interstate 80 opens in Salt Lake City. They have made a transcontinental highway.

If you had it in you, you could drive fifty miles. If you had enjoyed your stay, or enjoyed your history or wanted to make a day of it. If you were feeling slightly sentimental. Then you would have driven to see Promontory Point, where workers and bosses and tradesmen and hangers-on representing the Central Pacific and Union Pacific Railroad had come in 1869, in spring. They shaped themselves into an inverted V, like trees lining a river. They stood atop their engines, holding drinks, their arms extended like thin casements, and held their pose. There was a single gold spike. They hammered it into the ground. For luck.

BIBLIOGRAPHY

ON HIGHWAYS

Caro, Robert A. *The Power Broker: Robert Moses and the Fall of New York*. New York: Knopf, 1974.

Conover, Ted. *Routes of Man: Travels in the Paved World*. New York: Knopf, 2010.

"Daily Log of the First Transcontinental Motor Convoy: Washington, D.C. to San Francisco, Cal. July 7 to Sept. 6, 1919." U.S. Army, Transport Corps, Transcontinental Convoy: Records, 1919, Box 1. Eisenhower Presidential Library, Abilene, KS. Web. Accessed September, 2010. http://www.eisenhower.archives.gov/research/online_documents/1919_convoy/daily_log.pdf

Davies, Peter. *American Road: The Story of an Epic Transcontinental Journey at the Dawn of the Motor Age*. New York: Henry Holt, 2002.

Gutfreund, Owen D. *Twentieth-Century Sprawl: Highways and the Reshaping of the American Landscape*. New York: Oxford University Press, 2004.

Hessler, Peter. *Country Driving: A Journey Through China from Farm to Factory*. New York: Harper, 2010.

Huber, Uschi and Daniel Stemmrich,. *Uschi Huber: Autobahn*. Düsseldorf: Richter, 2000.

Kaszynksi, William. *The American Highway: The History and Culture of Roads in the United States*. Jefferson, NC: McFarland, 2000.

Landis, Leo. *Building Better Roads: Iowa's Contribution to Highway Engineering, 1904–1974*. Ames, Iowa: Center for Transportation Research and Education, Iowa State University, 1997.

Lewis, Tom. *Divided Highways: Building the Interstate Highways, Transforming American Life*. New York: Viking, 1997.

Multilingual Dictionary of Concrete: A Compilation of Terms in English, French, German, Spanish, Dutch, and Russian. Amsterdam: Elsevier Scientific, 1976.

Norton, Peter Daniel. *Fighting Traffic: The Dawn of the Motor Age in the American City*. Cambridge, MA: MIT Press, 2002.

Rose, Mark H. *Interstate: Express Highway Politics, 1939–1989*. Knoxville: University of Tennessee Press, 1990.

Swift, Earl. *The Big Roads: The Untold Story of the Engineers, Visionaries, and Trailblazers Who Created the American Superhighways*. Boston: Houghton Mifflin Harcourt, 2011.

ON JACKSON POLLOCK

Clark, T. J. *Farewell to an Idea: Episodes from a History of Modernism*. New Haven, CT: Yale University Press, 1999.

Fried, Michael. *Art and Objecthood: Essays and Reviews*. Chicago: University of Chicago Press, 1998.

Friedman, B. H. *Jackson Pollock: Energy Made Visible*. New York: McGraw-Hill, 1972.

Jachec, Nancy. *Jackson Pollock: Works, Writings, Interviews*. New York: Distributed Art Publishers, 2011.

Krauss, Rosalind E. *The Optical Unconscious*. Cambridge, MA: MIT Press, 1993.

Landau, Ellen G. *Jackson Pollock*. New York: Harry N. Abrams, 1989.

Naifeh, Steven, and Gregory White Smith. *Jackson Pollock: An American Saga*. New York: Crown Publishers, 1989.

O'Hara, Frank. *Jackson Pollock*. New York: Braziller, 1959.

Pollock, directed by Ed Harris. 2000: Sony Pictures Home Entertainment, 2001. DVD.

Potter, Jeffrey. *To a Violent Grave: An Oral Biography of Jackson Pollock*. New York: G.P. Putnam, 1985.

Solomon, Deborah. *Jackson Pollock: A Biography*. New York: Simon and Schuster, 1987.

Varnedoe, Kirk, and Pepe Karmel, eds. *Jackson Pollock: New Approaches*. New York: Museum of Modern Art, 1999.

ON DWIGHT EISENHOWER

Allen, Craig. *Eisenhower and the Mass Media: Peace, Prosperity, & Prime-time TV*. Chapel Hill: University of North Carolina Press, 1993.

Ambrose, Stephen E. *Eisenhower: Soldier and President*. New York: Simon and Schuster, 1990.

Eisenhower, Dwight D. *At Ease: Stories I Tell to Friends*. Garden City, NY: Doubleday, 1967.

Eisenhower, David. *Going Home to Glory: A Memoir of Life With Dwight D. Eisenhower, 1961–1969*. New York: Simon and Schuster, 2010.

Ledbetter, James. *Unwarranted Influence: Dwight D. Eisenhower and the Military-Industrial Complex*. New Haven, CT: Yale University Press, 2011.

Rayner, Richard. "Channelling Ike." *New Yorker*, April 26, 2010, 21–22.

Smith, Jean Edward. *Eisenhower in War and Peace*. New York: Random House, 2012.

ON JACK KEROUAC

Charters, Ann. *Kerouac: A Biography*. San Francisco: Straight Arrow Books, 1973.

Gifford, Barry and Lawrence Lee. *Jack's Book: An Oral Biography of Jack Kerouac*. New York: St. Martin's Press, 1978.

Kerouac, Jack. "After Me, the Deluge." *Los Angeles Times*, October 26, 1969. http://articles.latimes.com/2007/aug/31/entertainment/et-kerouac31/2

———. *Mexico City Blues: 242 Choruses*. 1959. Reprint, New York: Grove Press, 1994.

———. *On the Road: The Original Scroll*. New York: Penguin, 2007.

———. *The Sea Is My Brother*. New York: Da Capo, 2012.

———. *The Subterraneans*. 1958. Reprint, New York: Grove Press, 1994.

———. *The Town and the City*. 1950. Reprint, New York: Mariner Books, 1970.

———. *Vanity of Duluoz: An Adventurous Education, 1935–46*. 1968. Reprint, New York: Penguin, 1994.

———. *Visions of Cody*. 1972. Reprint, New York: Penguin, 1993.

Kerouac, Jan. *Nobody's Wife: The Smart Aleck and the King of the Beats*. Berkeley, CA: Creative Arts Books, 2000.

Nicosia, Gerald. *Memory Babe: A Critical Biography of Jack Kerouac*. Berkeley: University of California Press, 1994.

What Happened to Kerouac?, directed by Richard Lerner and Lewis MacAdams. 1986. Vidmark Entertainment, 1987; VHS.

LETTERS AND SOURCES

Many of the italicized letters in this book are prose centos that have been composed by rearranging sentences from published letters written or received by Eisenhower, Kerouac, or Pollock. Additional sentences were taken from the author's personal cor-

respondence. In some instances the language has been modified slightly.

Boyle, Peter G., ed. *The Churchill-Eisenhower Correspondence: 1953–1955*. Chapel Hill: University of North Carolina Press, 1990.

Eisenhower, Dwight D. *Letters to Mamie*. Garden City, NY: Doubleday, 1978.

Griffith, Robert. *Ike's Letters to a Friend, 1941–1958*. Lawrence, KS: University Press of Kansas, 1984.

Kerouac, Jack. *Jack Kerouac: Selected Letters Volume 1: 1940–1956*. New York: Penguin Books, 1996.

Kerouac, Jack and Johnson, Joyce. *Door Wide Open: A Beat Love Affair in Letters, 1957–1958*. New York: Viking, 2000.

Pollock, Jackson, and family. *American Letters, 1927–1947*. Malden, MA: Polity Press, 2011.

ARCHIVES

Electronic documents made available through both the Eisenhower Presidential Library and the Smithsonian Archives of American Art provided indispensable reading material that has been lightly quoted from.

I owe an even greater debt to the Henry W. and Albert A. Berg Collection at the New York Public Library and in particular to their unsparing staff, who were patient with me nearly every day during the month of July, 2008.

ADDITIONAL SOURCES

Adorno, Theodor. *Mimima Moralia: Reflections on a Damaged Life*. Trans. E. F. N. Jephcott. 1974. London: Verso, 2005. Reprint.

Ashbery, John. "The Invisible Avant-Garde." *ARTnews Annual* 34, (October 1968), 125–33.

———. *Reported Sightings: Art Chronicles, 1957–1987*. Cambridge, MA: Harvard University Press, 1991.

———. *Three Poems*. New York: Viking Press, 1972.

Barthes, Roland. *The Neutral: Lecture Course at the Collège de France, 1977–1978*. Trans. Rosalind Krauss and Denis Hollier. New York: Columbia University Press, 2005.

Benjamin, Walter. *The Arcades Project*. Trans. Howard Eiland and Kevin McLaughlin. Cambridge, MA: Harvard-Belknap Press, 1999.

Berardi, Franco. *After the Future*. Trans. Arianna Bove et al. Oakland, CA: AK Press, 2011.

Berman, Marshall. *All That Is Solid Melts into Air: The Experience of Modernity*. New York: Simon and Schuster, 1982.

Blanqui, Louis-Auguste. *Eternity by the Stars: An Astronomical Hypothesis*. Trans. Frank Chouraqui. New York: Contra Mundum Press, 2013.

Blumenson, Martin, ed. *The Patton Papers*. Boston: Houghton Mifflin, 1972.

Bois, Yve-Alain. *Painting as Model*. Cambridge, MA: MIT Press, 1993.

Boym, Svetlana. *Another Freedom: The Alternative History of an Idea*. Chicago: University of Chicago Press, 2010.

Butor, Michel. *Mobile: A Novel*. Trans. Richard Howard. Champaign, IL: Dalkey Archive Press, 2004.

Canneti, Elias. *Crowds and Power*. Trans. Carol Stewart. New York: Farrar, Straus and Giroux, 1984.

"Creation of the Eisenhower National Memorial." October 5, 2011. Online video. CSPAN. Accessed December, 2011.

Davis, Mike. *Planet of Slums*. London: Verso, 2007.

Dearborn, Mary. *Mistress of Modernism: The Life of Peggy Guggenheim*. Boston: Houghton Mifflin, 2004.

Deleuze, Gilles. *The Logic of Sense*. Trans. Mark Lester and Charles Stivale. New York: Columbia University Press, 1990.

Diaz, Bernal. *The Conquest of New Spain*. Trans. J. M. Cohen. Baltimore, MD: Penguin Books, 1963.

Dickens, Charles. *American Notes*. New York: Penguin Classics, 2001.

———. *Bleak House*. New York: Penguin Classics, 2003.

Doss, Erika Lee. *Benton, Pollock, and the Politics of Modernism: From Regionalism to Abstract Expressionism*. Chicago: University of Chicago Press, 1991.

Downs, Anthony. *Stuck in Traffic: Coping with Peak-Hour Traffic Congestion*. Washington, D.C.: Brookings Institution Press, 1992.

Elkins, James. *What Painting Is: How to Think About Oil Painting, Using the Language of Alchemy*. New York: Routledge, 1999.

Finkel, Jori. "Pollock Painting to Get the Getty Touch." *Los Angeles Times*, June 28, 2012. http://articles.latimes.com/2012/jun/26/entertainment/la-et-pollock-getty-20120626

Garber, Marjorie. *Sex and Real Estate: Why We Love Houses*. New York: Pantheon, 2000.

Gill, Anton. *Peggy Guggenheim: The Life of an Art Addict*. London: Harper Collins, 2001.

Girard, René. *Violence and the Sacred*. Trans. Patrick Gregory. Baltimore, MD: Johns Hopkins University Press, 1977.

Greenberg, David. *Presidential Doodles: Two Centuries of Scribbles, Scratches, Squiggles & Scrawls from the Oval Office*. New York: Basic Books, 2007.

Griffin-Pierce, Trudy. *Earth Is My Mother, Sky Is My Father: Space, Time, and Astronomy in Navajo Sandpainting*. Albuquerque: University of New Mexico Press, 1992.

Groys, Boris. *Going Public*. New York: Sternberg Press, 2010.

Guggenheim, Peggy. *Out of This Century: Confessions of an Art Addict*. New York: Universe Books, 1979.

Hegel, Georg Wilhelm Friedrich. *Lectures on the Philosophy of World History.* Trans. Hugh Barr Nisbet. Cambridge, UK: Cambridge University Press, 1981.

Hirshson, Stanley P. *General Patton: A Soldier's Life.* New York: Harper Collins, 2002.

Hocquard, Emmanuel. *Theory of Tables.* Trans. Michael Palmer. Providence, RI: O Blek Editions, 1994.

Humphrey, Doris. *The Art of Making Dances.* Highstown, NJ: Princeton Book Company, 1959.

Interim, directed by Stan Brakhage.1952. *Avant-garde: Experimental Cinema 1928–1954 Volume 2.* Kino International, 2007. DVD.

"Interview: Stephen Ambrose, Biographer and Historian." *Academy of Achievement.* Web. May 22, 1998.

"Irsay Buys Kerouac's Original in Auction." *Bloomberg News*, May 23, 2001. Web. Accessed November, 2006.

Jabès, Edmund. *The Book of Questions: Volume I.* Trans. Rosemarie Waldrop. Middleton, CT: Wesleyan University Press, 1991.

Jameson, Fredric. *Marxism and Form: Twentieth-Century Dialectical Theories of Literature.* Princeton, NJ: Princeton University Press, 1972.

Johnson, Dirk. "Chain of Grief for a Flagship University." *New York Times*, November 22, 2008.

"Judge Rules Kerouac Will a Forgery." *Associated Press*, July 28, 2009. Web.

Kafka, Franz. "Prometheus." *The Complete Stories.* Ed. Nahum Norbert Glatzer. New York: Schocken Books, 1995.

Kant, Immanuel. *Critique of the Power of Judgment.* Trans. Paul Guyer and Eric Matthews. Cambridge, UK: Cambridge University Press, 2000.

Kristeva, Julia. "Adolescence, a Syndrome of Ideality." *The Psychoanalytic Review* 94 (2007): 715–25.

Lacan, Jacques. *The Psychoses: 1955–1956*. Trans. Russell Grigg. 1993. Reprint. New York: W.W. Norton, 1997.

Le Clézio, J. M. G. *The Mexican Dream; or, The Interrupted Thought of Amerindian Civilization*. Trans. Teresa Lavender Fagan. Chicago: University of Chicago Press, 1993.

Lee, Alene. "Sisters." *Beatdom* 6 (2010): 13–18.

Leipold, J. D. "Reliving the 1919 Army Transcontinental Convoy 90 Years Later." *Army News Service.* June 18, 2009. http://www.army.mil/article/23071/reliving-the-1919-army-transcontinental-convoy-90-years-late

Levack, Lisa. "Past meets present on 2009 Transcontinental Convoy." *Army News Service,* June 15, 2009. http://www.army.mil/article/22702/

Mackinder, Halford. "The Geographical Pivot of History." *Geographical Journal* 23.4 (1904): 421–37.

Mayer, Bernadette. *Midwinter Day*. New York: New Directions, 1999.

Mitchell, W. J. T. *What Do Pictures Want? The Lives and Loves of Images*. Chicago: University of Chicago Press, 2005.

Moody, Rick. *Twilight: Photographs by Gregory Crewdson*. New York: Abrams, 2002.

Moses, Robert. "Haussmann." *Architectural Forum,* July 1942: 57–66.

Nietzsche, Friedrich. *On the Advantage and Disadvantage of History for Life*. Trans. Peter Preuss. Indianapolis, IN: Hackett, 1980.

Not Another Teen Movie, directed by Joel Gallen. 2001: Columbia Pictures Corporation.

Notley, Alice. "Jack Would Speak Through the Imperfect Medium of Alice." *Grave of Light: New and Selected Poems, 1970–2005*. Middletown, CT: Wesleyan University Press, 2006.

O'Hara, Frank. *The Selected Poems of Frank O'Hara*. Ed. Donald Allen. New York: Vintage, 1974.

Orozco, José Clemente. *An Autobiography*. Trans. Robert C. Stephenson. Austin: University of Texas Press, 1962.

Parezo, Nancy J. *Navajo Sandpainting: From Religious Act to Commercial Art*. Tucson: University of Arizona Press, 1983.

Phillips, Adam. *On Kissing, Tickling, and Being Bored: Psychoanalytic Essay on the Unexamined Life*. Cambridge, MA: Harvard University Press, 1993.

Quinn, Susan. *Furious Improvisation: How the WPA and a Cast of Thousands Made High Art Out of Desperate Times*. New York: Walker, 2008.

Reznikoff, Charles. *The Poems of Charles Reznikoff: 1918–1975*. Jaffrey, NH: Black Sparrow Books, 2005.

Rimbaud, Arthur. *A Season in Hell*. Trans. Donald Revell. Richmond, CA: Omnidawn, 2007.

Rizzolatti, Giacamo and Laila Craighero. "The Mirror-Neuron System." *Annual Review of Neuroscience* 27 (2004) 169–92.

Robertson, Lisa. *The Men: A Lyric Book*. Toronto: Boothug, 2006.

Ronell, Avital. *Stupidity*. Champaign: University of Illinois Press, 2002.

Rosler, Martha. *Culture Class*. New York: Sternberg Press, 2010.

Ross, Kristin. *The Emergence of Social Space: Rimbaud and the Paris Commune*. Minneapolis: University of Minnesota Press, 1988.

Roudinesco, Elisabeth. *Jacques Lacan & Co: A History of Psychoanalysis in France, 1925–1985*. Chicago: University of Chicago Press, 1990.

Rumsfeld, Donald. "Rumsfeld's Rules." *Wall Street Journal*, January 29, 2001.

Sahagún, Bernardino de. *General History of the Things of New Spain: Florentine Codex*. Trans. Charles E. Dibble and Arthur J. O. Anderson. Santa Fe, NM: School of American Research, 1970.

Salmon, Felix. "Selling Iowa's Pollock." *Portfolio.com*. August 13, 2008.

Saunders, Frances Stonor. *The Cultural Cold War: The CIA and the World of Arts and Letters*. New York: New Press, 2000.

Schlesinger, Stephen and Stephen Kinzer. *Bitter Fruit: The Story of the American Coup in Guatemala*. Cambridge, MA: Harvard University Press, 1999.

Schwarz, Arturo. *The Complete Works of Marcel Duchamp*. New York: Delano Greenridge, 2000.

Shakespeare, William. *The Tempest*. New York: Signet Classics, 1998.

Shelley, Percy. *Prometheus Unbound: A Variorum Edition*. Seattle: University of Washington Press, 1959.

Stein, Gertrude. *The Yale Gertrude Stein: Selections*. Richard Kostelanetz , ed. New Haven, CT: Yale University Press, 1980.

Stiegler, Bernard. *Technics and Time: The Fault of Epimetheus*. Trans. Richard Beardsworth and George Collins. Stanford, CA: Stanford University Press, 1998.

The National Advanced Driving Simulator at the University of Iowa. n.d. Web. Accessed June, 2009. http://www.nads-sc.uiowa.edu/

Twain, Mark. *The Adventures of Huckleberry Finn*. New York: Norton Critical Editions, 1998.

Valéry, Paul. *Dialogues*. Trans. William McCausland Stewart. New York: Pantheon Books, 1956.

Vernant, Jean-Pierre. "At Man's Table: Hesiod's Foundation Myth of Sacrifice." *The Cuisine of Sacrifice Among the Greeks*. Marcel Detienne, ed. Chicago: University of Chicago Press, 1989.

Vidal, Gore. *Palimpsest: A Memoir*. New York: Penguin Books, 1995.

Vitruvius. *On Architecture*. Trans. Richard Schofield. New York: Penguin Books, 2009.

WITHOUT WHOM

My thanks to Sarah Gorham, whose enduring support has been absolutely essential for this project. To the scrupulous and tireless editorial work of Kirby Gann, and to everyone at Sarabande who made the production of this book possible.

I am grateful for the support of the University of Iowa Museum of Art, the Jentel Foundation, the McKnight Foundation, and the Arrowhead Regional Arts Council. I am especially grateful to have had the chance to view *Mural* repeatedly at the UIMA for a suggested, voluntary donation of a few dollars.

So many people have read and offered feedback, encouragement and tough love to the work that's here, but I'm especially indebted to Amelia Bird, Ashley Butler, T Clutch Fleischmann, April Freely, Nick Kowalczyk, Nate McKeen, June Melby, Elena Passarello, and Andre Perry.

Thank you to my teachers: David Hamilton, Robin Hemley, Susan Lohafer, Mary Ruefle, Bonnie Sunstein.

I am especially grateful to John D'Agata. And to *Seneca Review* for publishing a portion of this book years ago.

To Caroline Casey, whose patience and acuity as a reader I could not have done without.

To my parents and my brothers.

To what I can remember and will never find out about my grandparents.

And to Lydia Diemer, who listened to every word here and made it possible to stop. This book is for anybody and nobody; my love is for her.

RILEY HANICK is an essayist, journalist, and translator whose writing has appeared in *The Sonora Review*, *Seneca Review*, *No Depression*, *eyeshot*, and *Labor World*. His work has received support from the Jentel and McKnight foundations and he has served as a writer-in-residence for the University of Iowa Museum of Art. His essay "The Pradelles" was among the notable essays in the 2010 *Best American* series. He teaches at Murray State University, where he is the Watkins Chair in Creative Writing and serves as the nonfiction editor for *New Madrid*.